Quality
27.95
.01

W9-CAH-960

CREATIVE
MOSAICS

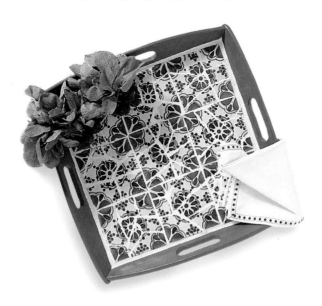

To Rita, our guru.

MANY THANKS TO:
the company COLART (Via Calabria 6 - Sesto Ulteriano, Milan) and in particular Mr. Mameli,
for kindly lending us the colors and paintbrushes with which we made the objects in this manual;
IKEA of Corsico (Via Marchesi 4), that supplied us with most of the objects reworked and photographed;
the company MAPEI (Via Jenner 4 - Milano) supplying us with the mortar for cracks and the tile glues;
Mr Albé of the company HOBBYLAND (Via P. Neglia 3 - Legnano, Milan) for the transparent glass glues, the resin for inclusion, the glass pearls, the cutting materials and the high quality cork.;
the company ADIT (Via Segrino, 8 - Sesto Ulteriano, Milan) for supplying the metal sheets and the embellishing equipment;
for the chapter dedicated to Ceramics: the company FORMENTINI (Strada Padana 254 - Vimodrone, Milano), in particular Luigi;
the store SOLELUNAMARE (Via Mercato 10 - Milan) for the Portuguese azulejos tiles;
the store GENEVIEVE LETHÙ (Via Piave 35 - Milan) for the photographic settings;
IL PARADISO DELLE SORPRESE (Corso di Porta Ticinese 62 - Milano) for the numerous objects photographed and illustrated in this book;
FRUTTISSIMA (Via Ravizza 11, Milano);
the company MIMMA GINI (Via S. Croce, 10 - Milano) for the materials and the carpets;
the company STILFORM s.r.l (Via Dell'Informatica, 15 - Viagnò di Gaggiano - Milano) for the mirror frames;
Mr. Ermani Brambillasca from Monza for the beautiful marble frames;
Cristina Sperandeo and Paola Masera for believing in us;
Rita Macchiavelli for spurring us on and encouraging us in these years;
our families: Silvana and Luca, Antonia and Angelo, for their support and their... coffee;
Beatrice and "Luchino" Arrigoni, who supported us in the studio;
last, but not least: Cristina, Paola, Barbara, Ivano, Lele, Alessia, Eddie Vedder, YouTwo, Ileana, Alex Delpiero, Maria and Luciano Valeron, Andrea Baguzzi for his vitality, and all those who made the realization of this manual possible.

Editor: Cristina Sperandeo

Photography: Alberto Bertoldi

Graphic design and layout: Paola Masera and Beatrice Brancaccio

Library of Congress Cataloging-in-Publication Data Available

10 9 8 7 6 5 4 3 2 1

Published by Sterling Publishing Company, Inc.
387 Park Avenue South, New York, N.Y. 10016
First published in 1998 by RCS Libri S.p.A, Milano
Under the title *Mosaico Creativo*
© 1998 by RCS Libri S.p.A.
Distributed in Canada by Sterling Publishing
c/o Canadian Manda Group, One Atlantic Avenue, Suite 105
Toronto, Ontario, Canada M6K 3E7
Distributed in Great Britain and Europe by Cassell PLC
Wellington House, 125 Strand, London WC2R OBB, England
Distributed in Australia by Capricorn Link (Australia) Pty Ltd.
P.O. Box 6651, Baulkham Hills, Business Centre, NSW 2153, Australia
Printed in China
All rights reserved

Sterling ISBN 0-8069-7140-I

Monica Cresci - Chiara Di Pinto

CREATIVE
MOSAICS

Sterling Publishing Co., Inc.
New York

CONTENTS

INTRODUCTION . 7

GLUES AND ADHESIVES . 8
CUTTING EQUIPMENT . 10
COLORS . 12

GLASS . 15

MATERIALS . 16
DECORATIVE CHRISTMAS BALLS 18
LAMP WITH COLORED GLASS
AND GLASS GEMS . 22
CANDLE HOLDER WITH PIECES OF SEA GLASS . . 26
VASE WITH GLASS GEMS . 26
AN INFINITE VARIETY OF REFLECTIONS 28
PICTURE FRAME WITH PAINTED GLASS 30

CORK AND WOOD . 33

MATERIALS . 34
CLASSIC TABLE . 36
MAKE UP BOX . 40
NEWSPAPER HOLDER WITH MORDANT DYE 46
A MIRROR OF STARS . 50
PLATE WITH TULIPS . 50

CERAMICS . 53

MATERIALS . 54
A SUNNY ROW OF AZULEJOS 56
HANGING VASE WITH TERRA-COTTA MOSAIC 62
PAVEMENT INSERT . 66
MARINE BEDSIDE TABLE . 68
STREET NUMBER . 70

SHELF WITH PLATE MOSAIC 70
TRAY WITH BLUE AZULEJOS. 72

NATURAL . 75
MATERIALS . 76
GARDEN TABLE . 78
DOORS LIKE ANCIENT ROADS. 82
SPOON WITH EGG SHELLS. 88
SEEDS AND MARBLE FRAGMENTS 92

METAL . 97
MATERIALS . 98
VASE WITH ARGENTINEAN WAVE 100
METAL EMBELLISHED ON BLUE GLASS. 104

WAX . 111
MATERIALS . 112
FRAME WITH STARS. 114
MOSAIC CANDLE WITH PERFUMED WAX. 118

WARDROBE WITH WAX FLOWERS 122
IDEAS FOR VALENTINES DAY. 126
THAT VAGUE TOUCH OF ANTIQUITY 128

PLASTIC . 131
MATERIALS . 132
LANTERN WITH RAINBOW REFLECTIONS 134
BREAKFAST TRAY IN TECHNICOLOR 138
FRAME IN MOSAIC . 142
AT THE TABLE WITH A TASTE OF SUMMER 142
"MUSICAL" VASE . 145

PAPER . 147
MATERIALS . 148
MOON AND STARS LAMP 150
A MOSAIC AS A COVER 154
MOSAIC BOX / ELEGANT HOLD ALL 158
ANCIENT GREEK TOUCH / VASE TO READ . . 159

INDEX . 160

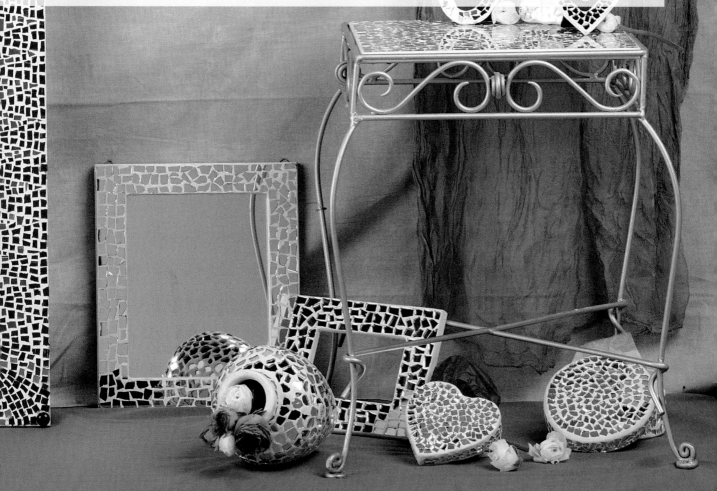

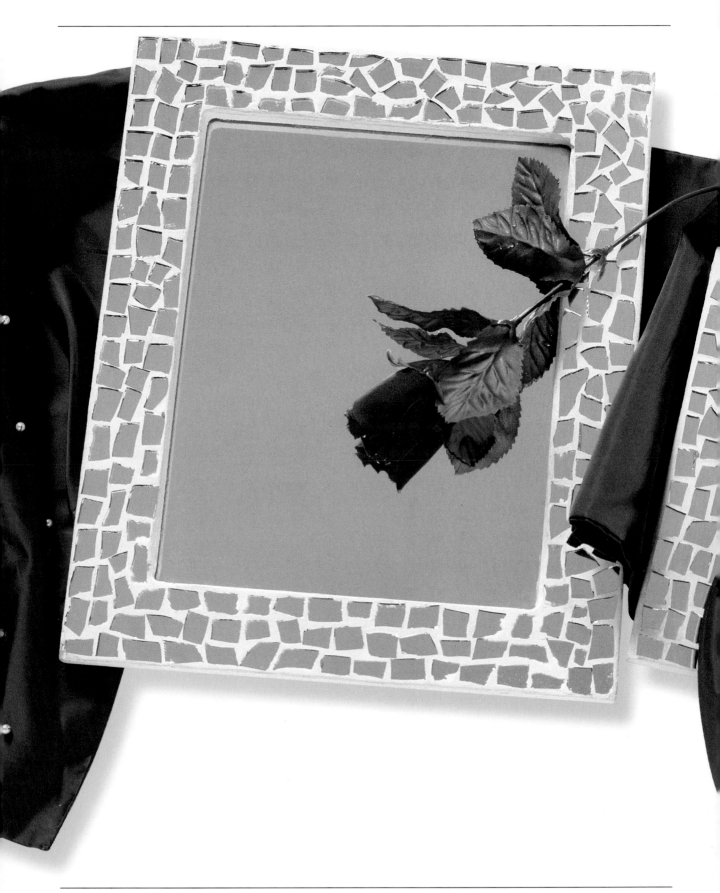

INTRODUCTION

Classical mosaic, made with pieces of marble and cut stone, constitutes one of the most ancient and fascinating techniques in the world of art. Even though it requires time and considerable skill, mosaic always gives exhilarating results. Although it may appear difficult to approach on a technical level, in this volume you will discover a long series of instructions that will enable you make mosaics with widely available materials that will stimulate your imagination.

This manual's structure facilitates a rapid and simple consultation: after an initial presentation of the basic materials required, the chapters have been divided according to the materials used. In these pages, we will show you some projects that are explained step by step, making it simple for you to learn the base techniques; following these projects you will find further creative examples that will allow you to progress your artistic capacities.

You will be able to create objects of real decorative impact in an easy, fast and inexpensive way, that are no less fascinating than those made with the classical technique.

No particular technical know how is necessary to create the objects we propose. Since the aim of this manual is to encourage your creativity and to help you to discover you hidden creative skills. From a table lamp to a tray to cutlery... the most ordinary objects can become a medium for your desire to create, to be transformed or reinvented with a touch of originality.

Wax, plastic, metal, glass and paper are some of the materials from which you can create objects of unexpected beauty, with simple equipment, patience and a touch of inventiveness.

All that remains is for us to wish you good work, hoping that this manual will stimulate your imagination and will satisfy your desire to create!

The authors

GLUES AND ADHESIVES

VINYL GLUE: works very well on porous materials like paper, cardboard and above all wood. It sticks well and dries fast. This type of glue is available in paint supply stores, stationary shops and in hardware stores.

TWO COMPONENT EPOXY GLUE: this is an extremely strong and versatile glue, sold in hardware and paint supply stores. It is made up of two components that should be mixed in equal parts before use. It is very fast drying.

SILICONE: indicated for large surfaces, silicone is generally used as a sealer for cracks, and is also works well on glass, metal and all non porous materials.
GLUE FOR WAX: is only available in specialized stores. It is sold in a gel

form and in small quantities. It is usually used to adhere wax on wax; alternatively you use the wax from a melted candle as glue. As it dries it will glue the two parts together well.
TILE GLUE: this glue is a white colored, spongy

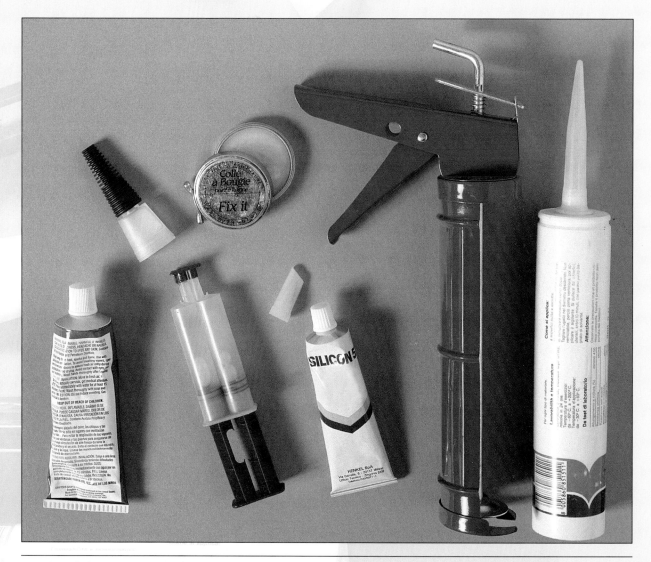

paste. It works well on ceramic, terra-cotta or wood, but it takes a long time to dry thoroughly. It should be applied using a fairly large spatula. The best adhesion can be achieved with a minimum thickness of 3mm.
TRANSPARENT GLASS GLUE: this is a specific glue, it adheres glass onto any surface. It allows the glass to maintain its transparency and own color without unattractive smudges.

TRANSPARENT GLUE FOR PLASTICS: a specific glue for plastic that does not make it turn yellow or corrode with time. It is rather expensive, and therefore, suitable for small surfaces.
UNIVERSAL GLUE: transparent and very strong glue, that dries in a few seconds and guarantees a good hold even on the most difficult materials.
It can be purchased in stationary or paint supply stories.

GLUE FOR PAPER AND CARDBOARD: absolutely non-toxic and suitable only for paper and cardboard and for small modifications. It is available in stationary stores or paint supply stores.
ADHESIVE PAPER STRIP: useful for masking surfaces and for temporary fixtures. It has the advantage of not leaving any trace once removed.
WHITE OR COLORED CEMENT: used to fill the

gaps between one mosaic piece and another, it is sold in a powder form. It is to be mixed with water, and according to necessity, with a vinyl glue. It is inexpensive.

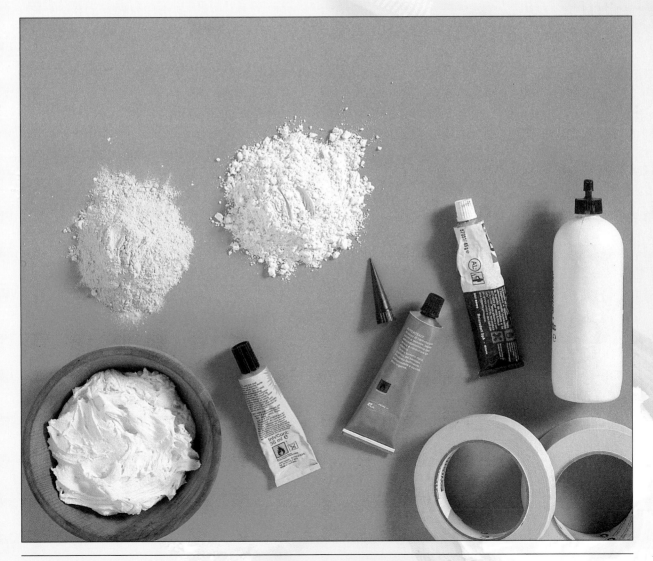

CUTTING EQUIPMENT

SCISSORS: are a very useful instrument for cutting paper, cardboard, sheets of metal etc., as long as they are always well sharpened. In order to achieve good results it is advisable to use them for straight and simple cuts.
CUTTER: useful above all for irregular or more complicated cuts. As the blade becomes blunt, it is advisable to break the segments using the marked traces; in this way it will always be kept perfectly sharp.

SCALPEL: an instrument

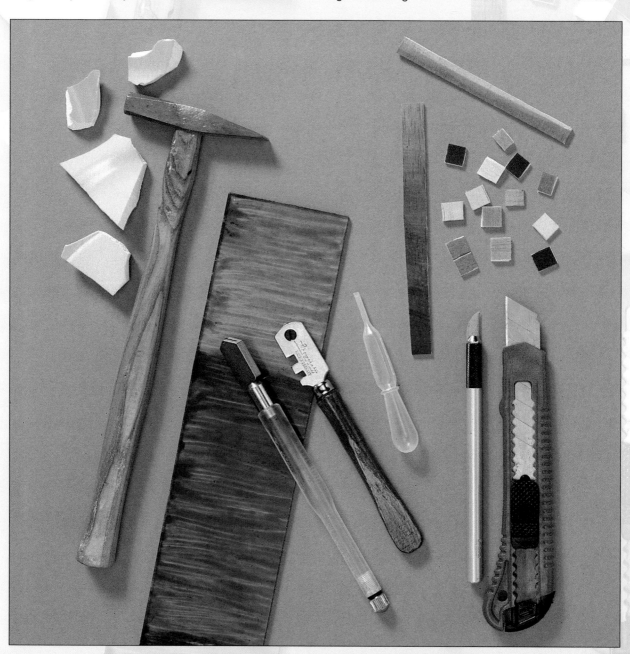

usually used by graphic designers, it is particularly sharp and allows very precise incisions even on materials such as plastic, metal and cardboard.

GLASS CUTTER WITH OR WITHOUT OIL: specific instrument for cutting glass, it consists of a rolling head, with or without an oil reservoir, that cuts glass on the surface; to break the glass off entirely, hit its surface several times. Very precise cuts can be achieved. Nonetheless, in order to obtain good results several attempts are necessary. It is available in specialized stores.
KNIFE: this common household appliance is suitable for cutting wax and, in general, very plastic materials. It can also be useful in spreading cement should a spatula not be available.
HAMMER: for breaking glass and tiles in an irregular way. You should wrap the material to be broken up in a cloth before hitting it with the hammer: in this way you can prevent dangerous bits of material flying out.

COLORS

ACRYLIC COLORS: are water based, without odor and do not stain. They can be used on surfaces such as wood, paper and cardboard. It is possible to obtain uniform as well as shaded cover.
When very diluted, acrylic colors become transparent, similar to watercolor. They can be applied with a normal paintbrush and can be mixed. They work well on white cement.

GLASS COLORS: these are transparent colors specifically for glass that have to be diluted with turpentine; for this reason they are not completely odorless and can stain.

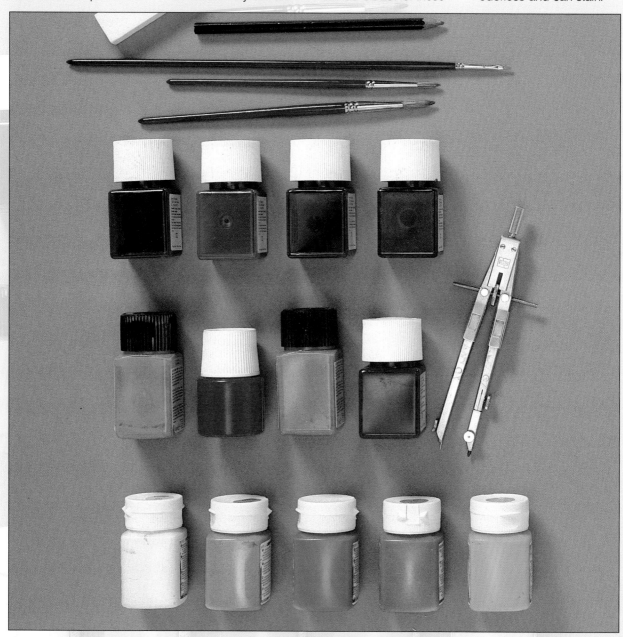

They can't be mixed with acrylic colors or with water, but are the only kind of color suitable for glass.

COLORED PIGMEMTS: not often used because they are rather expensive. They are useful for the coloration of cement and can usually can be mixed with acrylic and tempera colors.

SPATULAS: indispensable instrument for applying glue and cement, and available in different forms and dimensions. They are available in paint supply stores and fine art stores.

PAINTBRUSHES: numerous types are available, in different materials and forms of bristle. Sizes vary depending on the object you want to paint. After usage they should be washed carefully and placed head down, so as not to damage the bristle.

TRIANGLE: indispensable instrument that does not need presentations. It is useful for very precise drawings, when accurate measurements are needed.

CLOTH AND SPONGE: useful for the removal of excess cement that has been used to close gaps. They should always be kept clean.

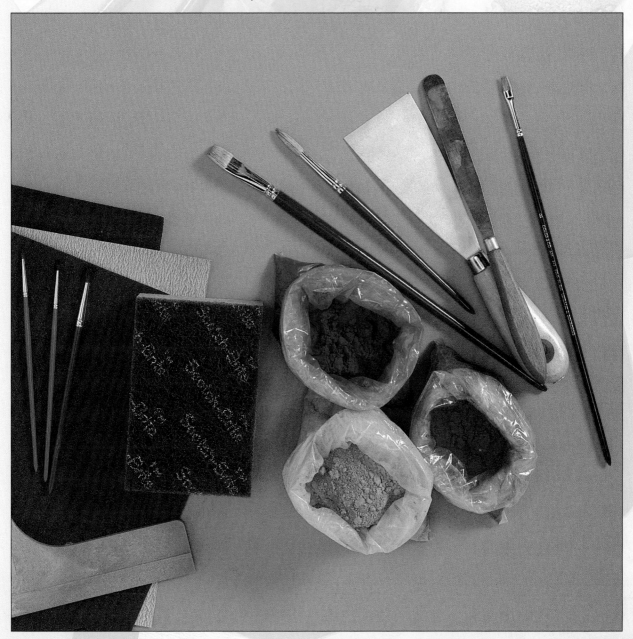

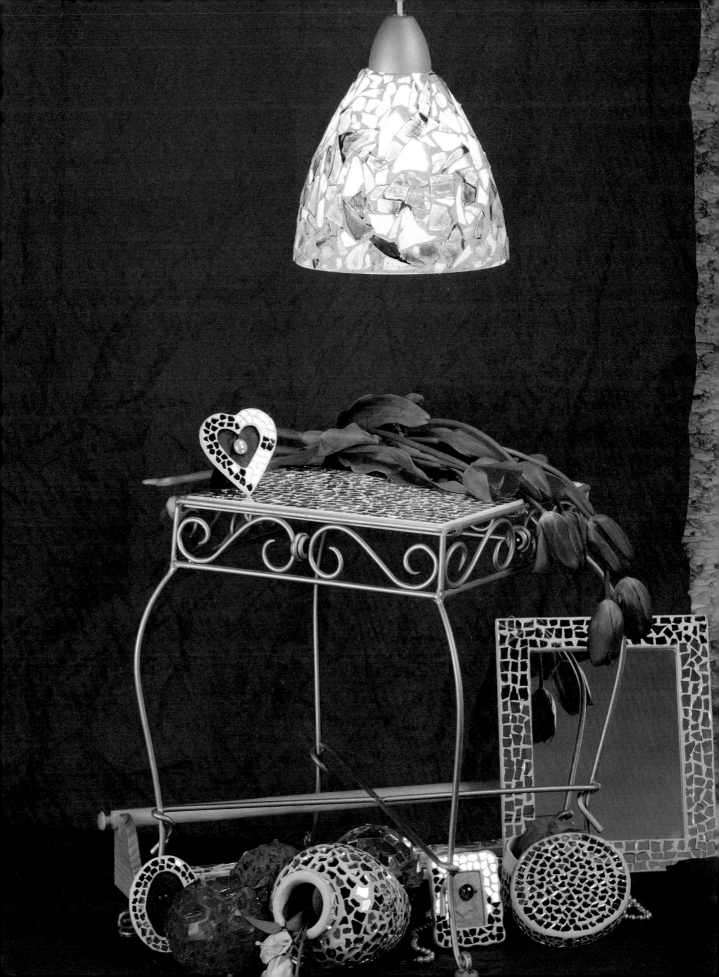

GLASS

MATERIALS

TRANSPARENT GLASS: available at your preferred glass merchant's or, if possible you could rummage around amongst his rejects, since it not necessary for the glass to be of prime quality.

COLORED GLASS: obtained by painting layers of transparent color with suitable colors. The colors are available at any well-stocked color supply store.

BROKEN GLASS: in spite of its fame for bringing bad luck, broken glass is a wonderful material for mosaics. So, don't throw it away!

PRE CUT GLASS BITS: sold in packets of 50 pieces; they are handy to use because they have already been shaped.

GLASS GEMS: pretty and colored, glass gems are ideal for the creation of special and bright mosaics. They are sold in bags of, generally, 30 pieces.

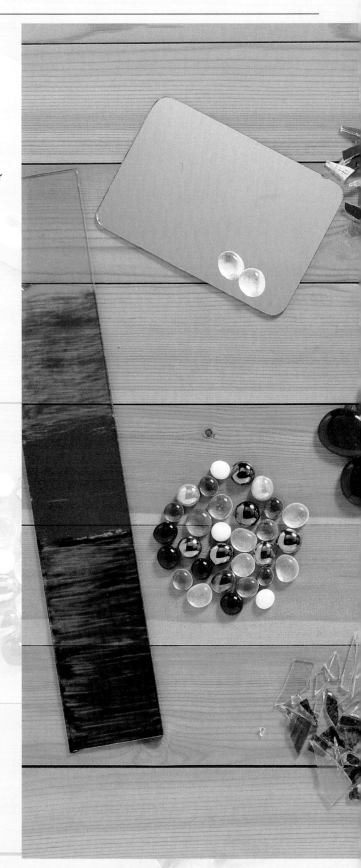

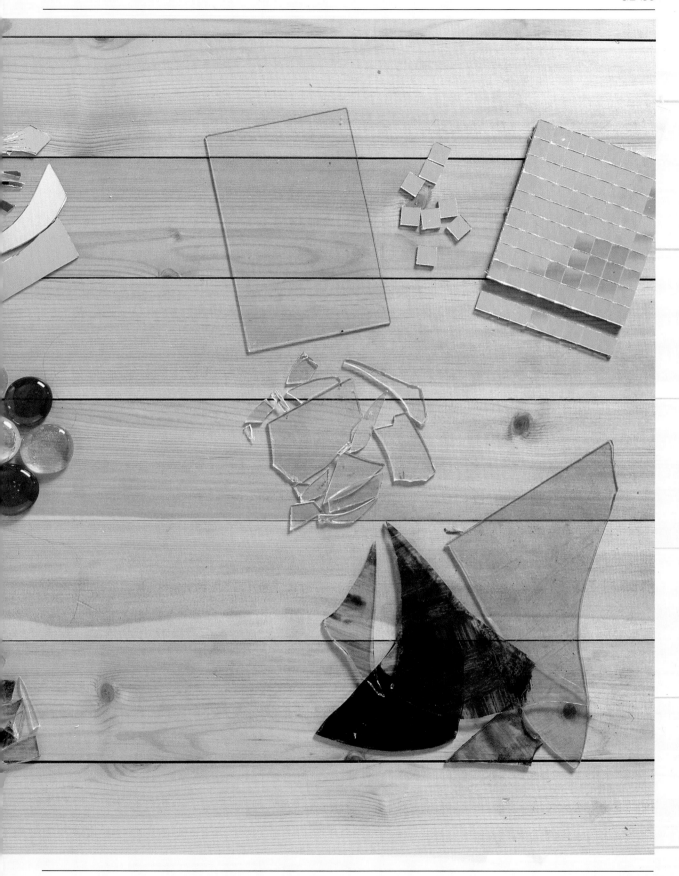

DECORATIVE CHRISTMAS BALLS

Bright and sparkling, decorative Christmas balls - made with colored glass - as in the illustration are an ideal alternative to traditional Christmas tree decorations.

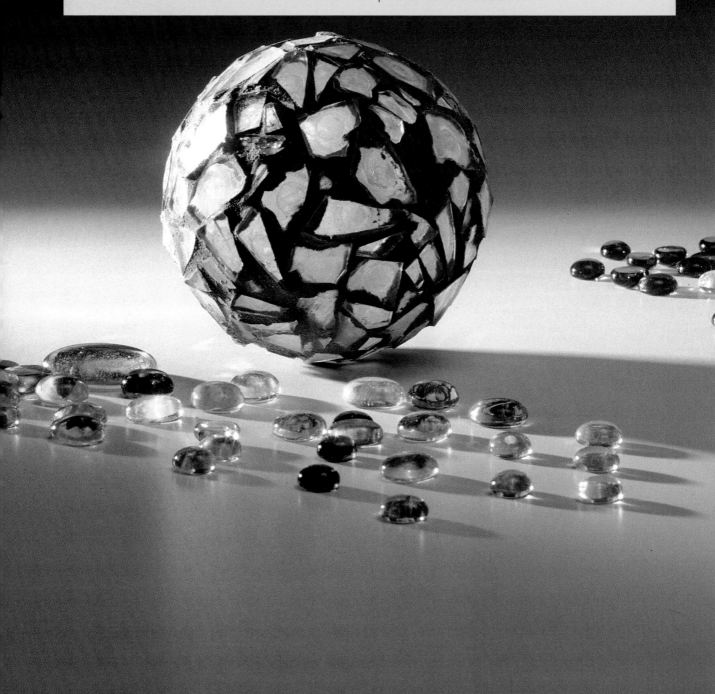

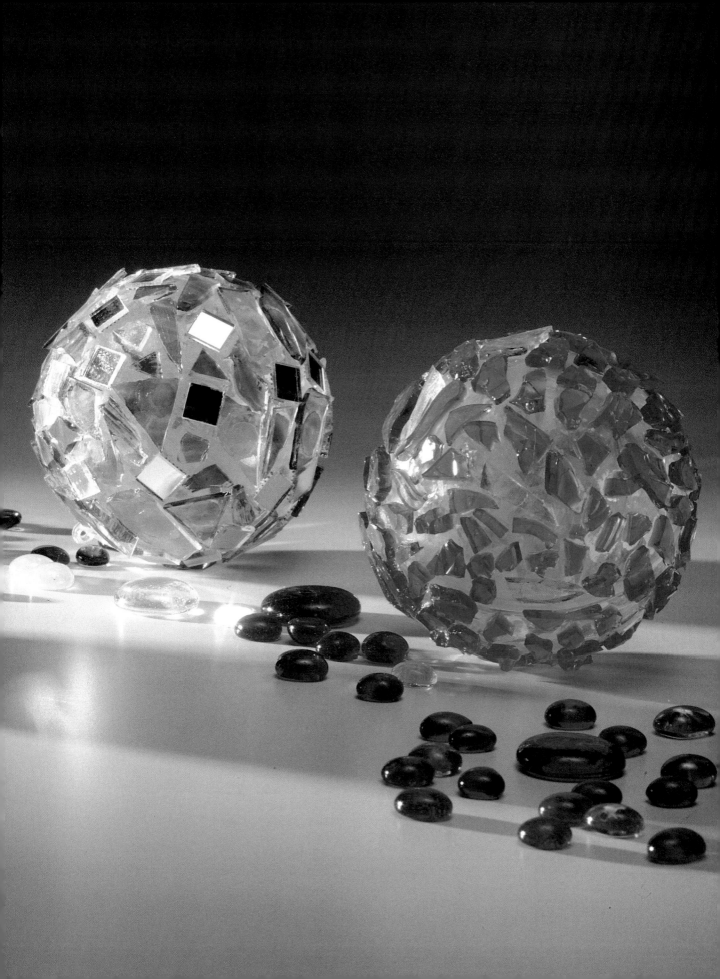

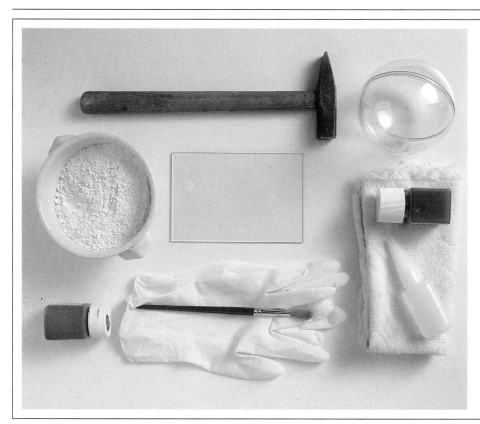

REQUIRED MATERIALS

A TRANSPARENT PLASTIC BALL
WHITE CEMENT FOR FILLING IN
THE GAPS TRANSPARENT GLASS
A HAMMER
LATEX (OR RUBBER) GLOVES
A FINELY POINTED N.4 BRUSH
YELLOW GLASS PAINT
ACRYLIC GREEN PAINT
WATER
COTTON CLOTH
FINE GRAINED SANDPAPER
RAPID DRY GLUE

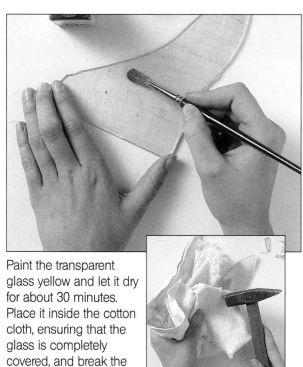

Paint the transparent glass yellow and let it dry for about 30 minutes. Place it inside the cotton cloth, ensuring that the glass is completely covered, and break the glass with a firm stroke.

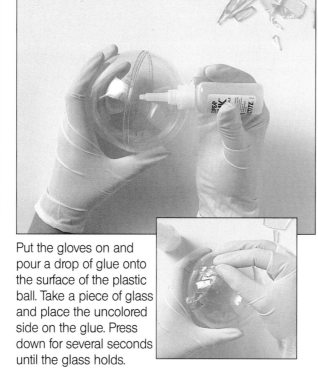

Put the gloves on and pour a drop of glue onto the surface of the plastic ball. Take a piece of glass and place the uncolored side on the glue. Press down for several seconds until the glass holds.

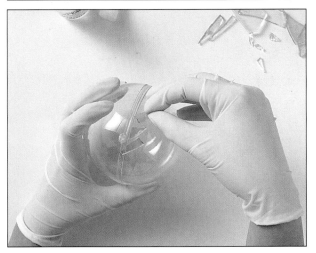

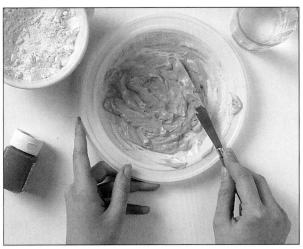

Repeat this operation with all the glass bits, alternating with pieces of transparent glass. You will need to be patient at this stage and you should proceed slowly, without haste. Carry on with the gluing until the entire ball has been covered, giving each piece of glass the necessary time to dry firmly onto the surface.

Mix together 6 teaspoons of cement, or mortar for filling in the gaps, with 1/2 glass of water in a plastic plate. Stir well until a homogenous and fluid substance has been obtained. Add the acrylic green and carry on stirring until the color is perfectly dissolved and the paste is smooth but not too watery. You can use the spatula for this operation.

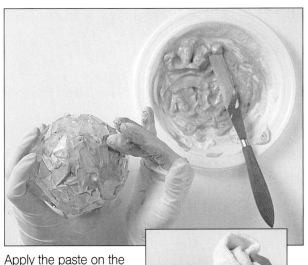

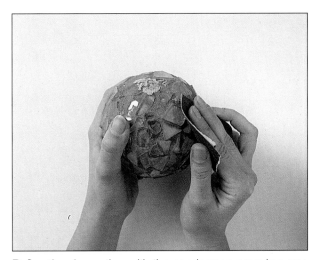

Apply the paste on the mosaic using the spatula, so that the cement penetrates all the gaps. You can also use your fingers to help you. Leave to dry for 10 minutes. Clean the ball with a damp cloth or with a sponge, until the mosaic shines through.

Refine the decoration with the sandpaper, removing any excess cement that was not possible to remove with the sponge. You will obtain an even and smooth mosaic in this way. As a finishing touch rub a dry cotton cloth over the ball.

LAMP WITH COLORED GLASS AND GLASS JEMS

What kind of light should you give to a special room or corner of the house? All you need to decorate an old lampshade with elegance or reinvent a simple glass lampshade are some pieces of colored glass, a few transparent gems and your imagination. Just as the lampshade illustrated on this page.

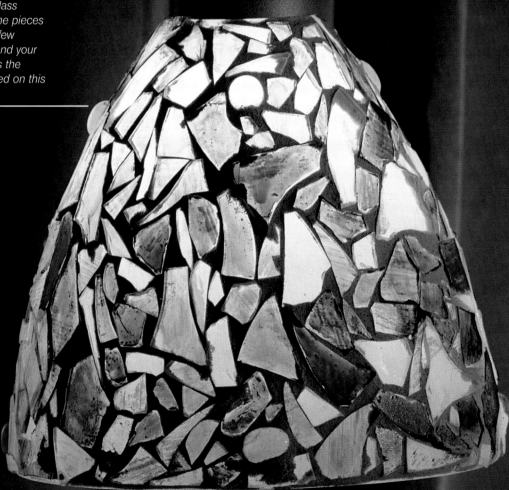

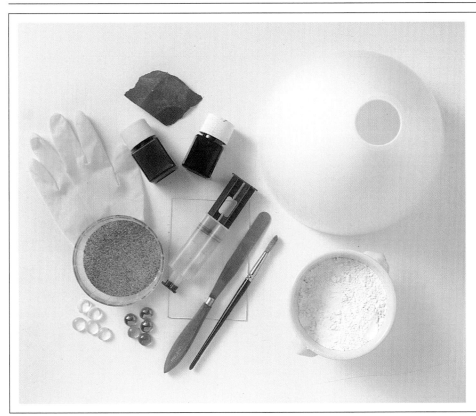

A TRANSPARENT GLASS
LAMPSHADE
COLORS FOR BLUE AND
TURQUOISE GLASS
TRANSPARENT AND BLUE GEMS
GLASS GLUE
FINE TIPPED NO. 3 PAINTBRUSH
SAND
MEDIUM GRAINED SANDPAPER
COTTON CLOTH
HAMMER

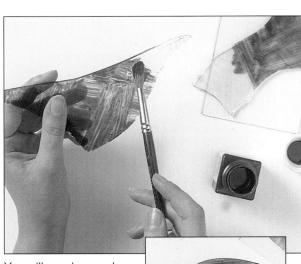

You will need several pieces of blue and bits of turquoise glass for the creation of this lampshade. Paint the pieces of transparent glass carefully and leave them to dry for about 30 minutes.

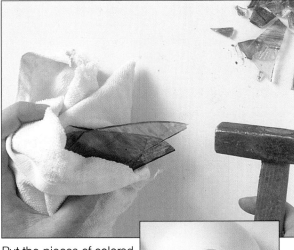

Put the pieces of colored glass into the cotton cloth and break them with a hammer. Mix the two component epoxy glue in a small plastic plate and apply a layer on one part of the lampshade using the spatula.

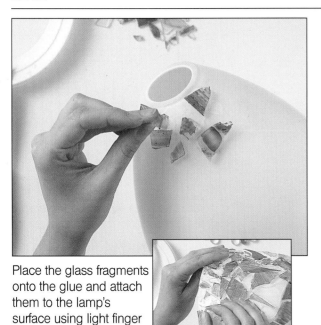

Place the glass fragments onto the glue and attach them to the lamp's surface using light finger pressure. Arrange the transparent and blue glass gems here and there.

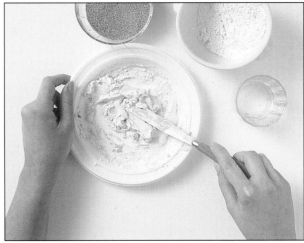

Prepare the cement, mixing 9 spoons of white cement for filling in cracks with 6 spoons of common sand and 1/2 glass of water. Stir accurately, remembering that the paste should not become too soft and liquid, otherwise it will take longer to dry, and consequently your creation will take much longer to be completed.

Apply the cement using the spatula, making sure that all the spaces between the glass bits are filled in. You can use your fingers to help you distribute the cement more evenly. Leave to dry for about 15 minutes. Remember that the drying times for cement vary, depending on the amount of water used and air humidity.

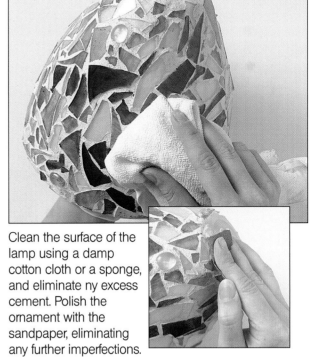

Clean the surface of the lamp using a damp cotton cloth or a sponge, and eliminate ny excess cement. Polish the ornament with the sandpaper, eliminating any further imperfections.

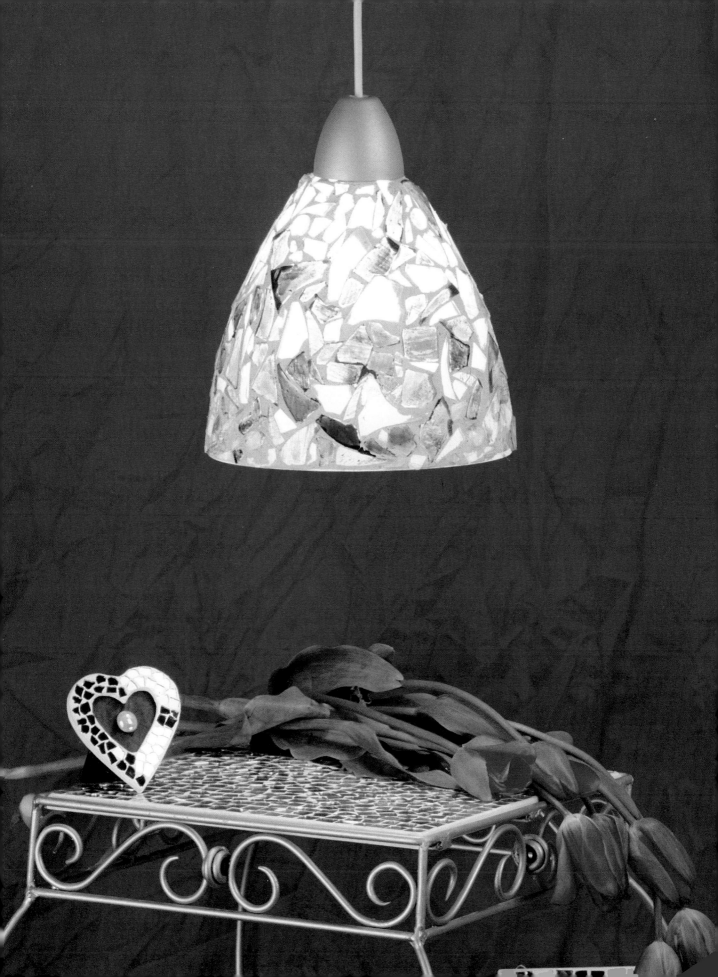

CANDLE HOLDER WITH BITS OF SEA GLASS

Made by reassembling glass bits that have been gathered on the seashore into a mosaic, these candleholders are ideal for a special dinner party where the suffused candlelight will set a mood for the evening.

VASE WITH GLASS GEMS

Essential in its form and decoration, this vase is the perfect accompaniment to predominantly white furnishing. Obviously the color of the cement and the gems can vary according to personal taste.

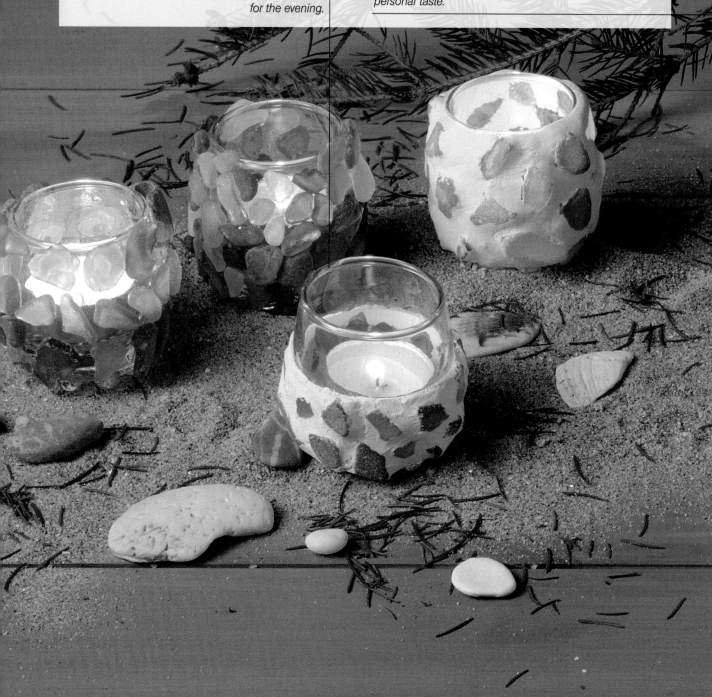

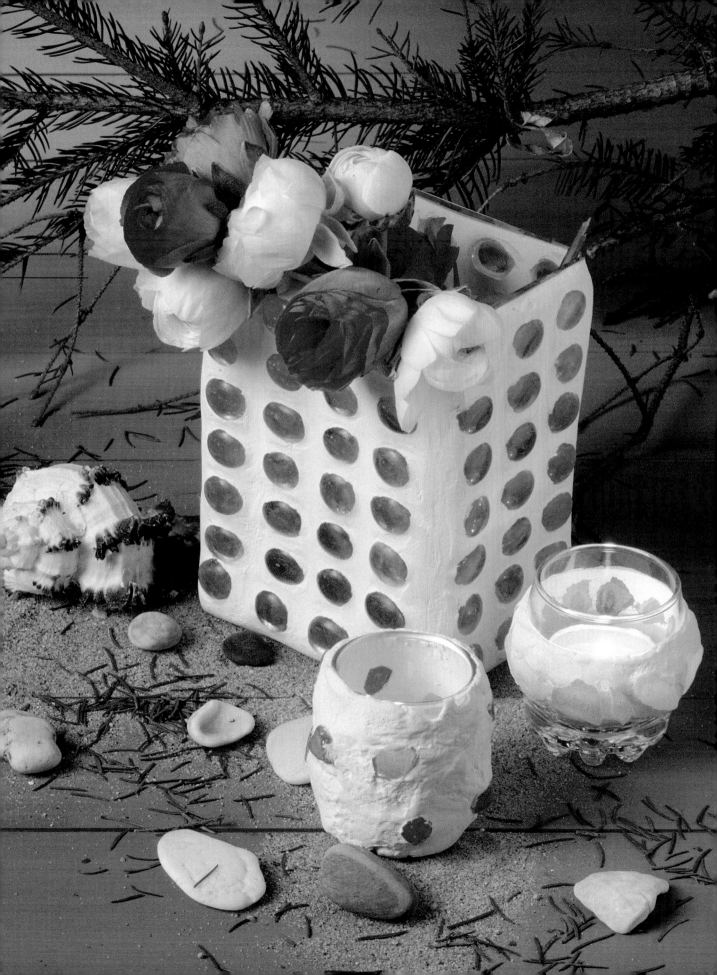

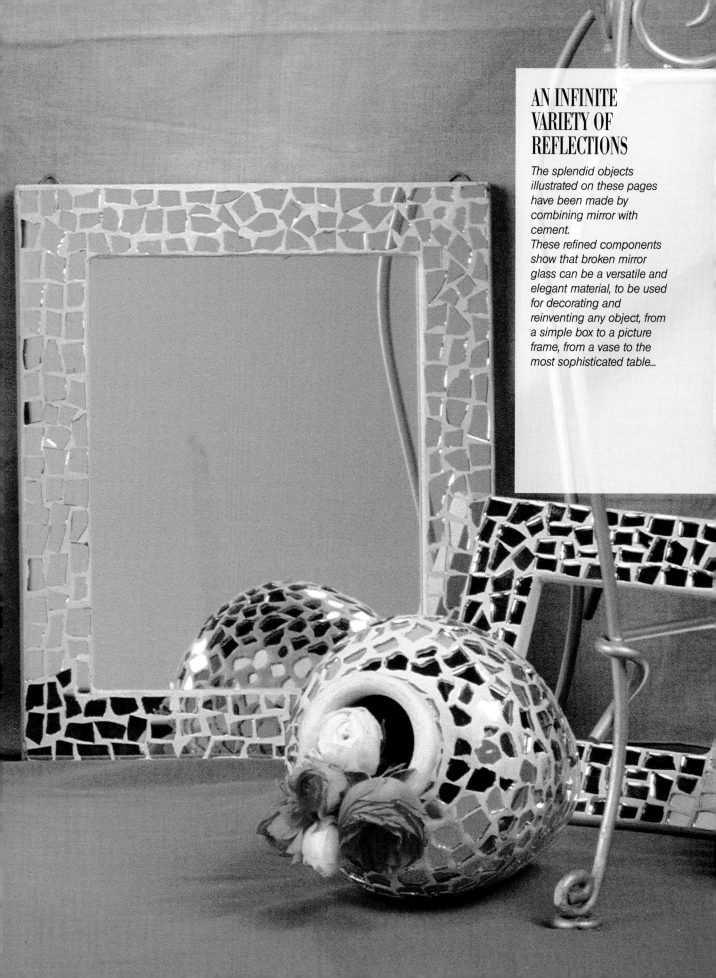

AN INFINITE VARIETY OF REFLECTIONS

The splendid objects illustrated on these pages have been made by combining mirror with cement.
These refined components show that broken mirror glass can be a versatile and elegant material, to be used for decorating and reinventing any object, from a simple box to a picture frame, from a vase to the most sophisticated table...

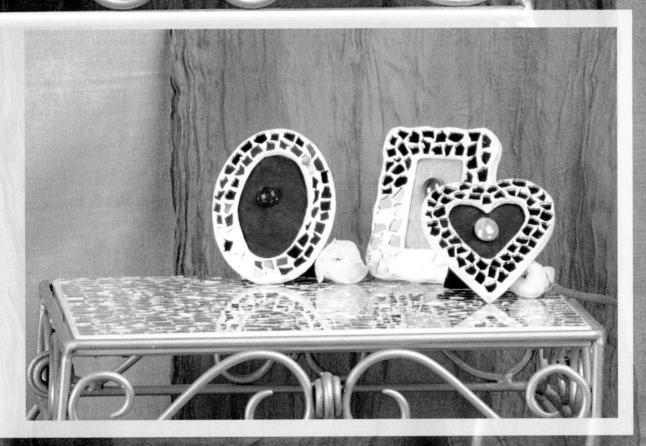

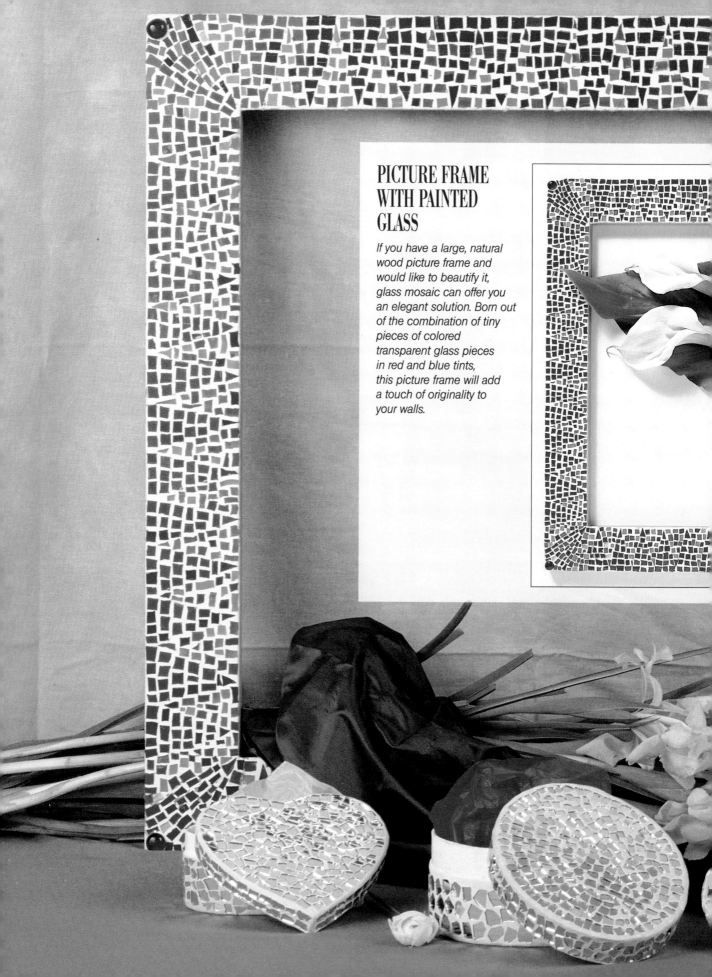

PICTURE FRAME WITH PAINTED GLASS

If you have a large, natural wood picture frame and would like to beautify it, glass mosaic can offer you an elegant solution. Born out of the combination of tiny pieces of colored transparent glass pieces in red and blue tints, this picture frame will add a touch of originality to your walls.

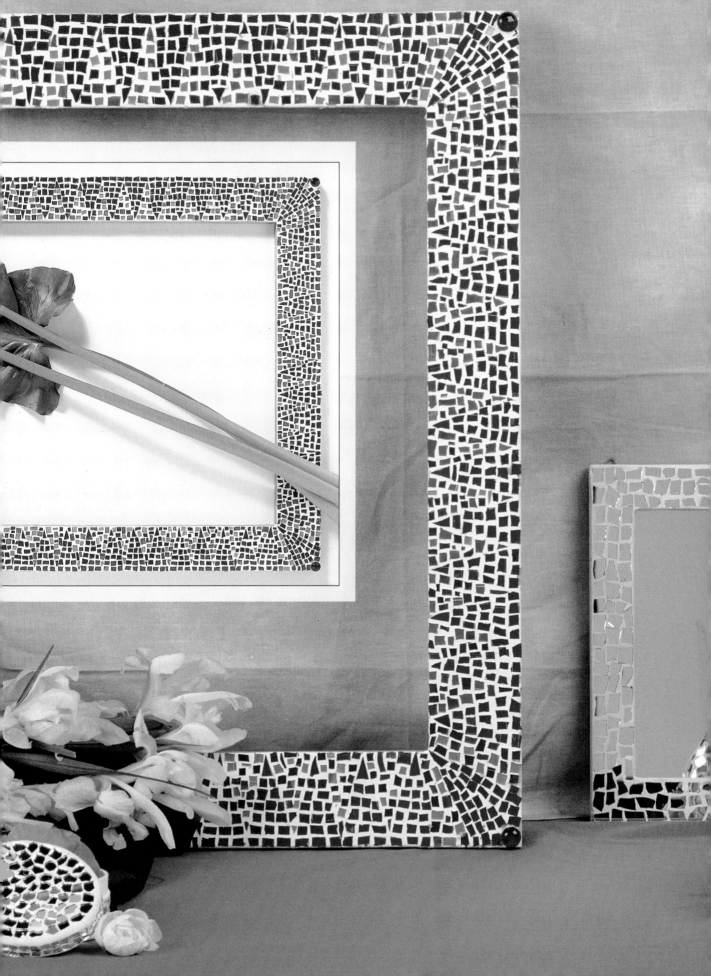

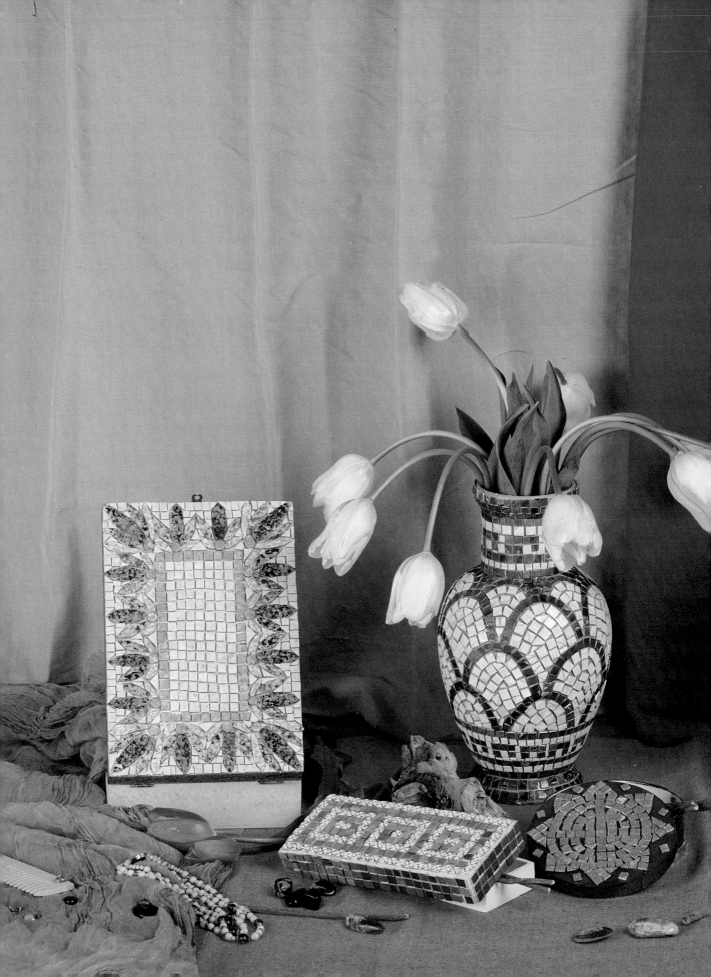

CORK AND WOOD

MATERIALS

BALSA WOOD FOR MODEL MAKING: thanks to its decorative effects and its extraordinary versatility - it's light, easy to cut, work and paint with any color - balsa wood is particularly suitable for the realization of mosaics. It is available in sheets of 10 x 100 cm with a thickness that varies from 1mm up to around 2 cm.

SPONGY BALSA: this effect can be obtained by padding the balsa with different hues of color, one on top of the other, using a regular natural sponge

SHEET OF GOLD: if you would like to attain a pretty, shiny gold - as illustrated in the next pages - you will have to utilize a gold sheet. This extremely thin sheet of pinchbeck (available in paint supply and fine art stores) is to be used for decorative purpose. This technique requires a bit of attention as gold sheets are very fine and crumble easily. Furthermore, the wood should be prepared for gilding with a special paint.

The gold effect can also be achieved using the various types of gold paints on sale.

FULL COLOR: this is the easiest color to obtain in chromium painting, by mixing acrylic color and water (very diluted if a special glaze is required).

It is easy to apply with a paintbrush, and does not emit unpleasant odors, it is clean to use and available in a wide range of colors.

MARBLE EFFECT: this is a technique best left to those with considerable artistic talent. The effect is obtained by superimposing thin layers of paint creating marble -like veins with a fine pointed paintbrush.

CORK: light and easy to use, it is the ideal material to be cut into in to mosaic squares. It is sold in panels or sheets for isolated use as well as by the meter. It can also be recycled from note pad boards.

Thickness varies widely, according to usage; for the following projects you will need to use cork that is no higher that 1cm , that is easily cut.

CLASSIC TABLE

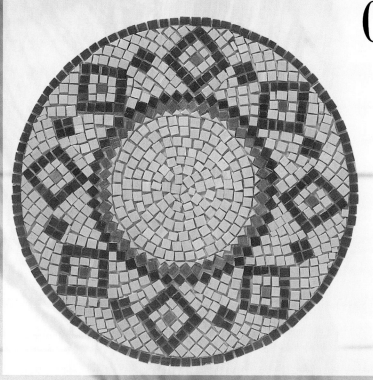

This table is ideal for anyone who loves the classical style, and will add refinement and beauty to the furnishing of your home. It is easy to make, requiring squares of colored cork applied on a geometric motif, typical of marble mosaics.

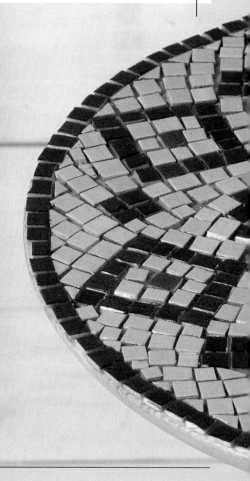

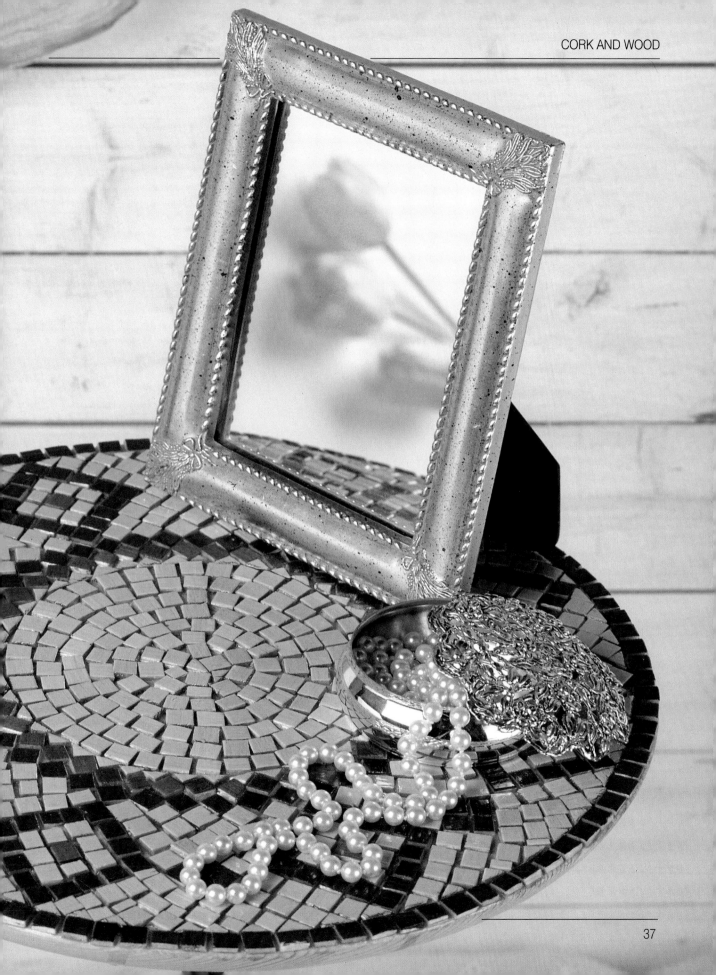

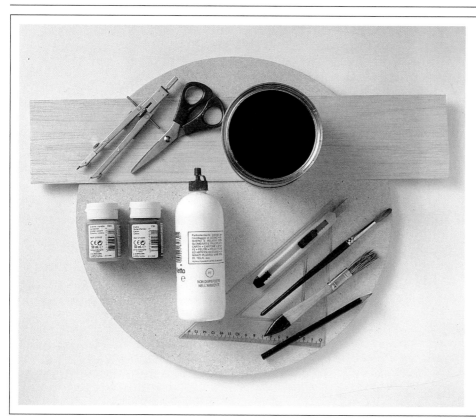

REQUIRED MATERIALS

A WOODEN DISC OF 40 CM DIAMETER
A SHEET OF CORK 2 MM THICK
A COMPASS
SHINY FLATTING
SCISSORS
VINYL GLUE
ACRYLIC COLOR
A TRIANGLE
A CUTTER
PAINTBRUSHES
PENCIL

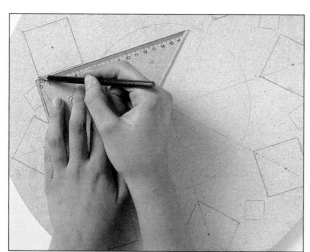

Draw a circle of 15cm at the center of the wooden disc using the compass. Prepare the mosaic pattern with the help of the triangle, drawing a series of equidistant squares on the surface of the disc.

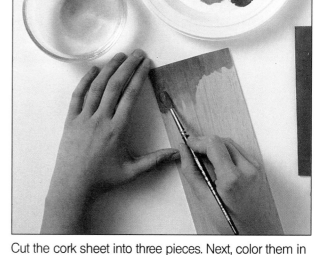

Cut the cork sheet into three pieces. Next, color them in a full tint using three shades of the same color using water and acrylic white paint. The more water added, the lighter the color will become. This will allow the veins of the wood to show through. When one adds more white color, the shade will become more opaque.

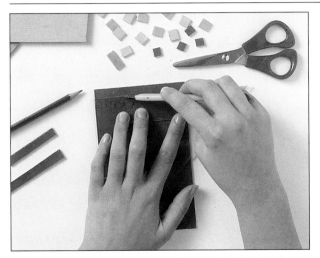

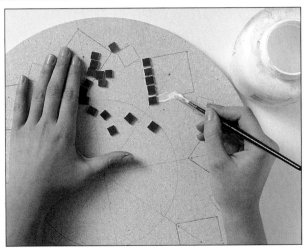

Score the three slabs of cork with a well sharpened pencil and divide each one into regular squares sized 1 x 1 cm. Then, incise the sheets into small lines with the cutter (following the pencil traces) and then cut them into squares with the scissors. Proceed in the same way for all three sheets, dividing the bits into different piles according to color.

Apply the vinyl glue with a fine paintbrush following the trace of the first of the squares that you have penciled in on the wood disc. If necessary, dilute the glue with some water. Start arranging the darker squares in an orderly fashion, leaving space between one square and the next. Continue in this way until you have filled in the entire penciled in pattern.

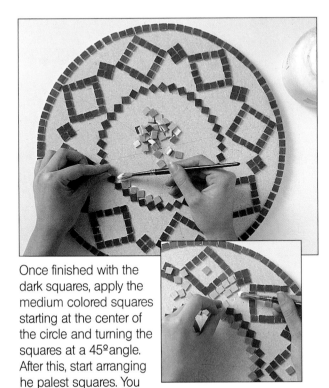

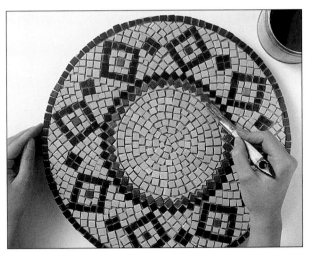

Once finished with the dark squares, apply the medium colored squares starting at the center of the circle and turning the squares at a 45º angle. After this, start arranging he palest squares. You can cut the squares in half to help you attach them to particularly difficult corners. Try to place them in the neatest possible way, to avoid unattractive differences.

Making sure that the glue has dried completely, apply a generous coat of shiny flatting that should also penetrate all the nooks and crannies. Flatting (or paint for ships) is ideal for protecting and cementing your work as it is totally resistant and water proof. When the first layer of flatting has dried, apply another layer, and if you would like to achieve a particularly glossy result, you can also apply a third coat.

MAKE UP BOX

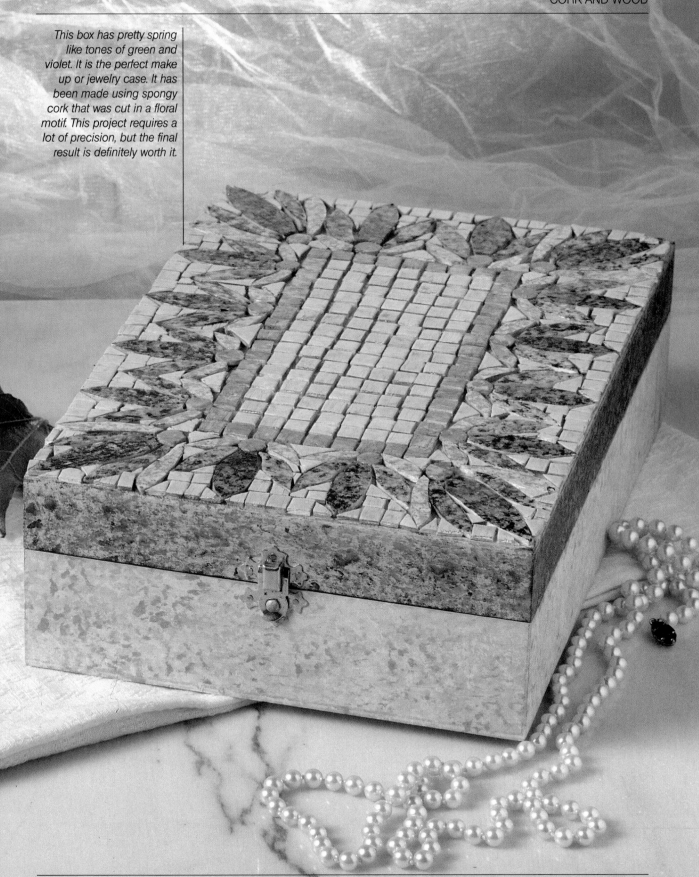

This box has pretty spring like tones of green and violet. It is the perfect make up or jewelry case. It has been made using spongy cork that was cut in a floral motif. This project requires a lot of precision, but the final result is definitely worth it.

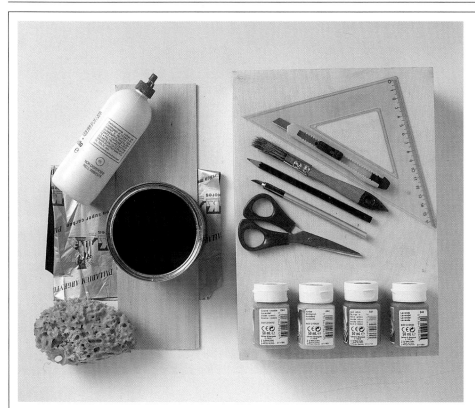

REQUIRED MATERIALS

A WOODEN BOX
A SHEET OF CORK, 2 MM THICK
ACRYLIC COLORS
NATURAL SPONGE
SCALPEL
VINYL GLUE
FLATTING
CARBON PAPER
A PAINTBRUSH
A PENCIL
A SQUARE
A CUTTER
SCISSORS

Firmly place a sheet of carbon paper on the cover the box, being careful not to let it slip. Copy the drawing that you have prepared on a separate sheet of paper with a sharpened pencil. You can either copy the pattern suggested in this book or invent you own, so long as it has the same measurements as the box cover.

Prepare the light green color in a plastic plate. Dampen a sponge with water and dip it into the paint. Start speckling the sheet of cork. The pressure used should be delicate but firm. At this stage, keep some paper close at hand where you can get rid of any excess color if the sponge becomes too imbued with color. An excessive quantity of color would risk ruining the lightness of your creation.

Superimposing various tones of color, creating a certain depth, will make the sponging appear fresher and prettier. Finally, for a more luminous effect, add some touches of white or very light green. Use the same procedure in applying the other colors. Here we have used three tones of green - light, medium and dark - and two tones of pink, one very pale for the edges and another more violet shade for the center of the leaves.

Copy the outline of the leaves of the same color (for example all the dark ones) on the cork sheets using a well sharpened pencil and the carbon paper. Be careful not to press too hard when you are copying, because cork is very delicate and is easily marked. It is also wise to remember that cork, like all types of wood, has a fiber side along which it is easier to cut: try to find this side in order to make cutting easier.

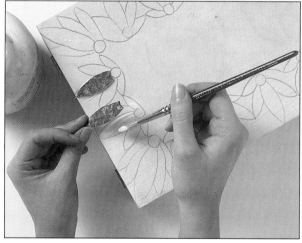

Cut the various pieces using the scalpel. To be on the safe side, cut out some extra pieces just in case some break.

Apply a coat of the vinyl glue on the drawing you previously made on the box, using a medium sized paintbrush. Start applying the first leaves, making sure that you they are attached in the exact position marked by the drawing.

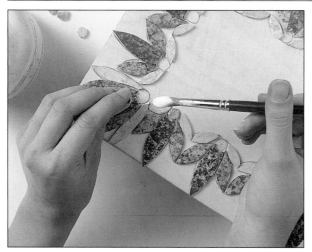

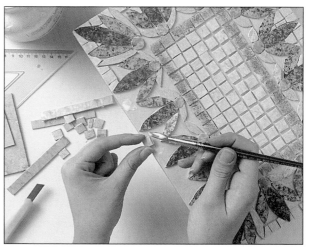

Once you have positioned all the leaves, attach the violet discs at the center of the leaves. Remember to leave a small space between one square and the next. In this case the vinyl glue will help you, it does not dry straightway and so will give you time to adjust the positioning of the squares.

Cut out square shapes sized 1 x 1 cm from the pink and light green cork using the square, cutter and scissors. Then adhere these on the box filling in the empty gaps and completing the drawing. The final result will be pleasing and harmonic if the work has been carried out in a uniform way.

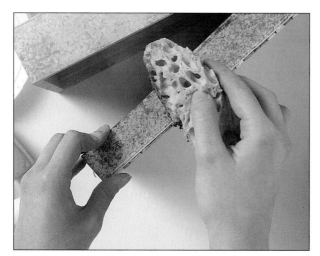

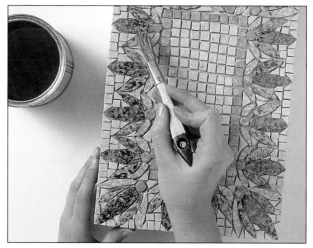

Allow the glue to dry completely. Then begin polishing the make up box by passing a sponge over the green and pink sides, using the same technique as for the sponging of the cork.

When the box is completely dry, apply a coat of shiny flatting in order to fill in the gaps and protect the artwork. You can apply further layers of flatting for a more polished effect.

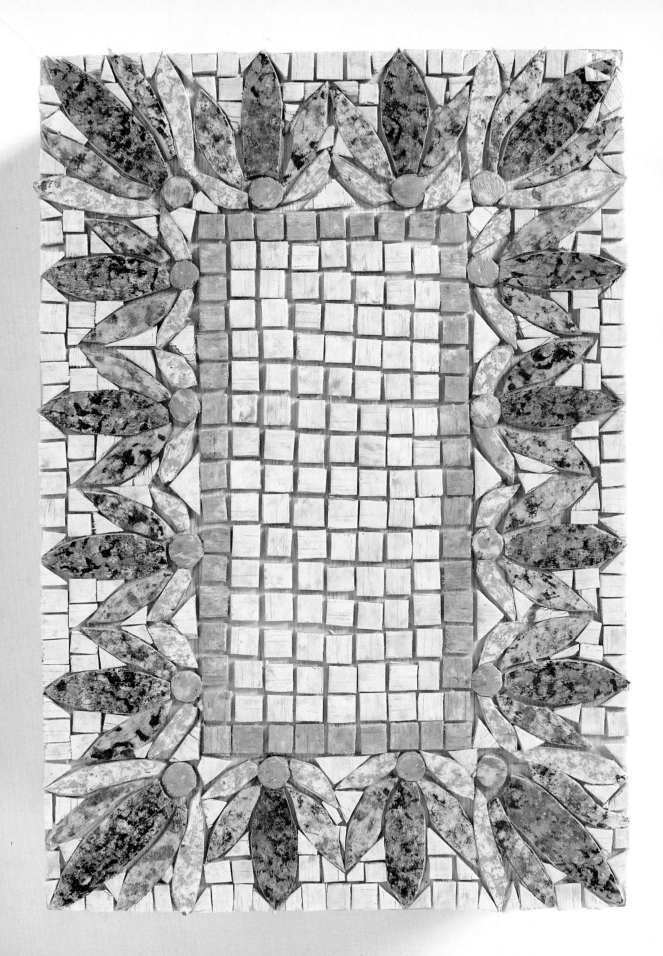

MAGAZINE HOLDER WITH MORDANT DYE

Let's beautify an object that is usually only considered useful!

This magazine holder made out of unrefined wood has been decorated with squares of different dimensions that have been treated with wood dye that stimulates diverse shades of wood.

For a greater protection and to give it a natural look, the magazine holder has been polished with plenty of opaque flatting. It is particularly easy and fast to make and is ideal for those of you who wish to familiarize yourselves with the mosaic technique.

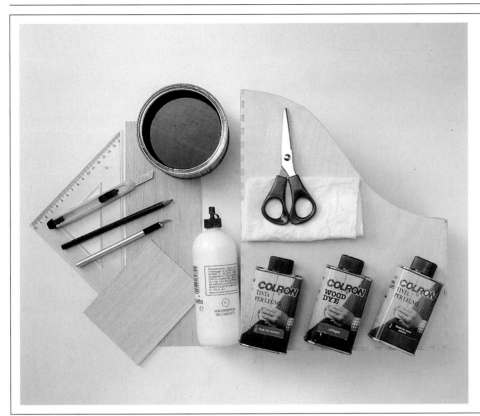

REQUIRED MATERIALS

3 PIECES OF CORK, THICK 1,5MM
A WOODEN MAGAZINE HOLDER
3 WOOD DYES IN THE SHADES: CHERRY, EBONY AND TEAK
SCISSORS
CUTTER OR SCALPEL
VINYL GLUE
FLATTING
A TRIANGLE
A PENCIL
SOFT CLOTH

MORDANT DYE IS A VARNISH THAT GIVES WOOD A TRANSPARENT COLOR SIMILAR TO VARIOUS TYPES OF WOOD FROM DARK EBONY TO RED CHERRY.

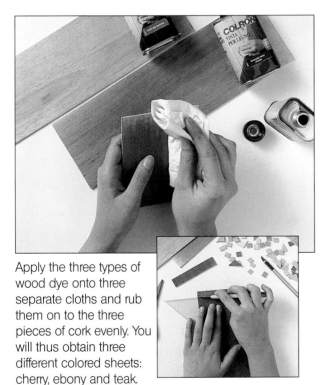

Apply the three types of wood dye onto three separate cloths and rub them on to the three pieces of cork evenly. You will thus obtain three different colored sheets: cherry, ebony and teak.
Cut the cork into 1 x 1 cm squares (that will remain this size), and then cut the others into 2 x 2 cm sized squares. Then, in half to create small triangles.

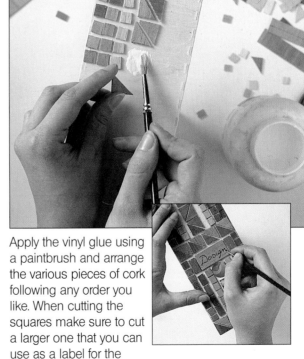

Apply the vinyl glue using a paintbrush and arrange the various pieces of cork following any order you like. When cutting the squares make sure to cut a larger one that you can use as a label for the contents of the file. Once you have finished, polish it with one or more coats of flatting.

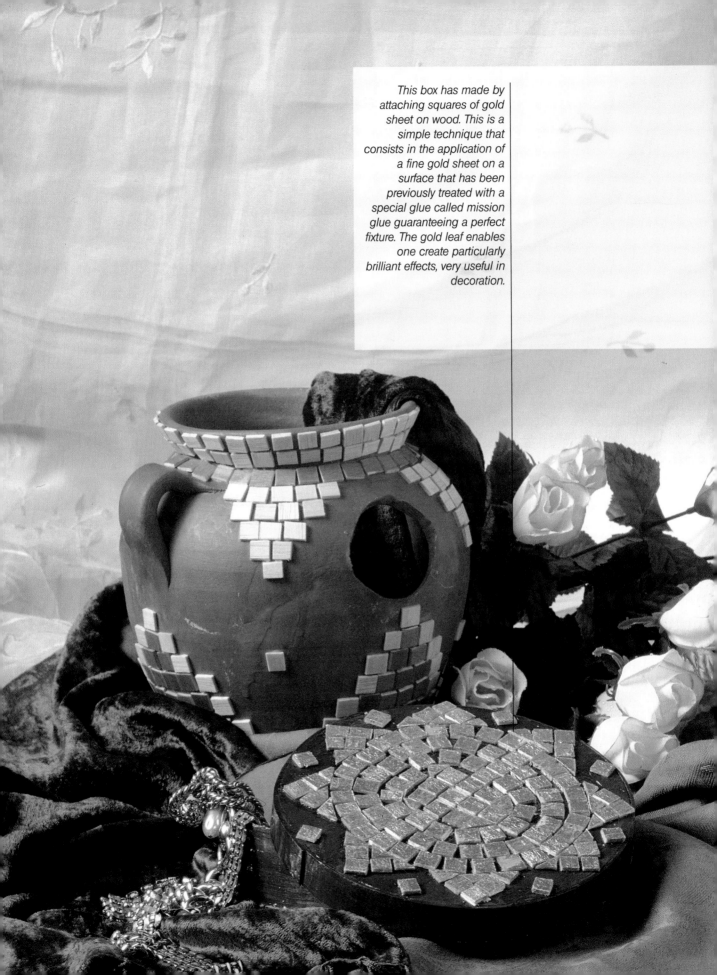

This box has made by attaching squares of gold sheet on wood. This is a simple technique that consists in the application of a fine gold sheet on a surface that has been previously treated with a special glue called mission glue guaranteeing a perfect fixture. The gold leaf enables one create particularly brilliant effects, very useful in decoration.

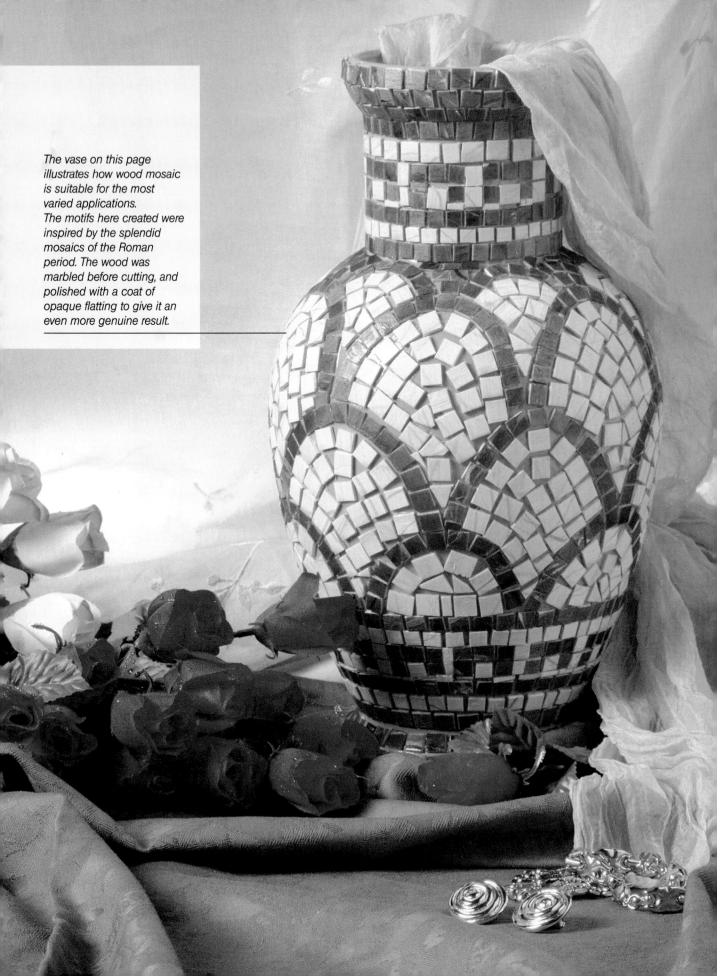

The vase on this page illustrates how wood mosaic is suitable for the most varied applications. The motifs here created were inspired by the splendid mosaics of the Roman period. The wood was marbled before cutting, and polished with a coat of opaque flatting to give it an even more genuine result.

A MIRROR OF STARS

A wooden stand especially made by a carpenter was used to make this mirror. The squares were cut into irregular triangles colored with various shades of green to create light and shade effects highlighting the red stars. To make perfectly shaped stars draw star shapes on cardboard first, and use these as a template for the stars to be drawn on the wood.

PLATE WITH TULIPS

With its warm and bright colors this plate is clearly easy and quick to make. The choice of floral design makes it an ideal furnishing accessory for a house in the country.

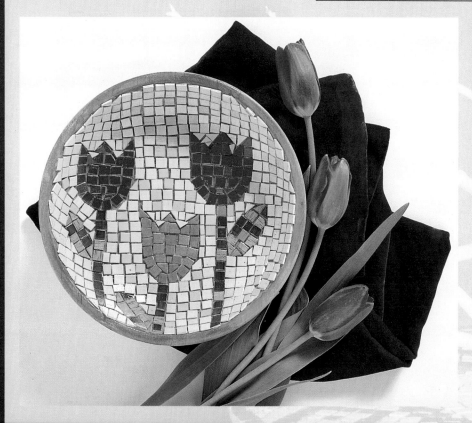

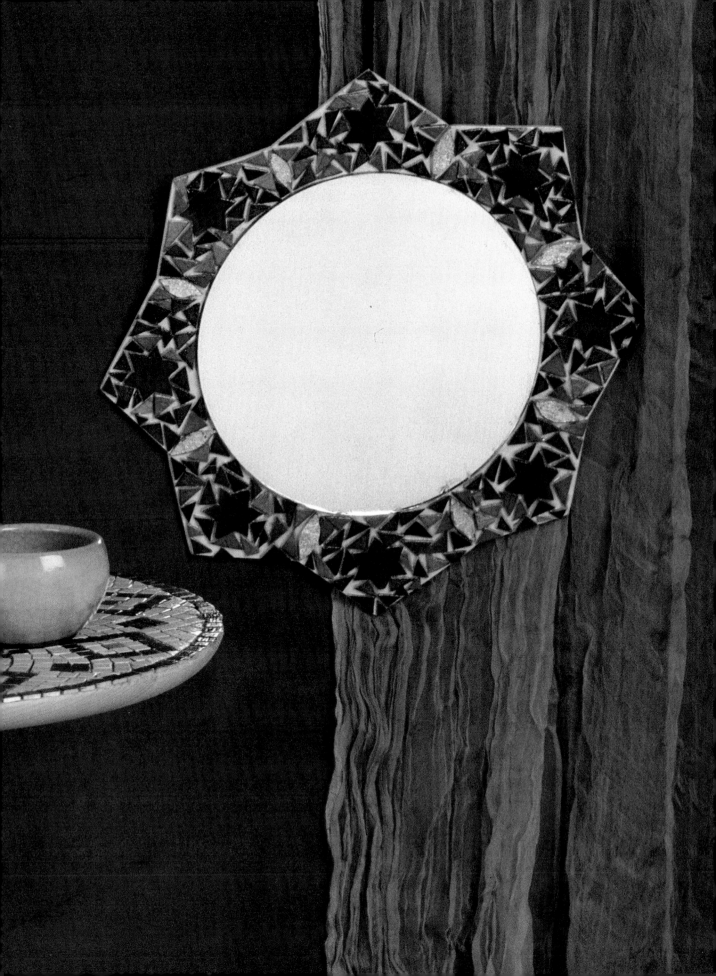

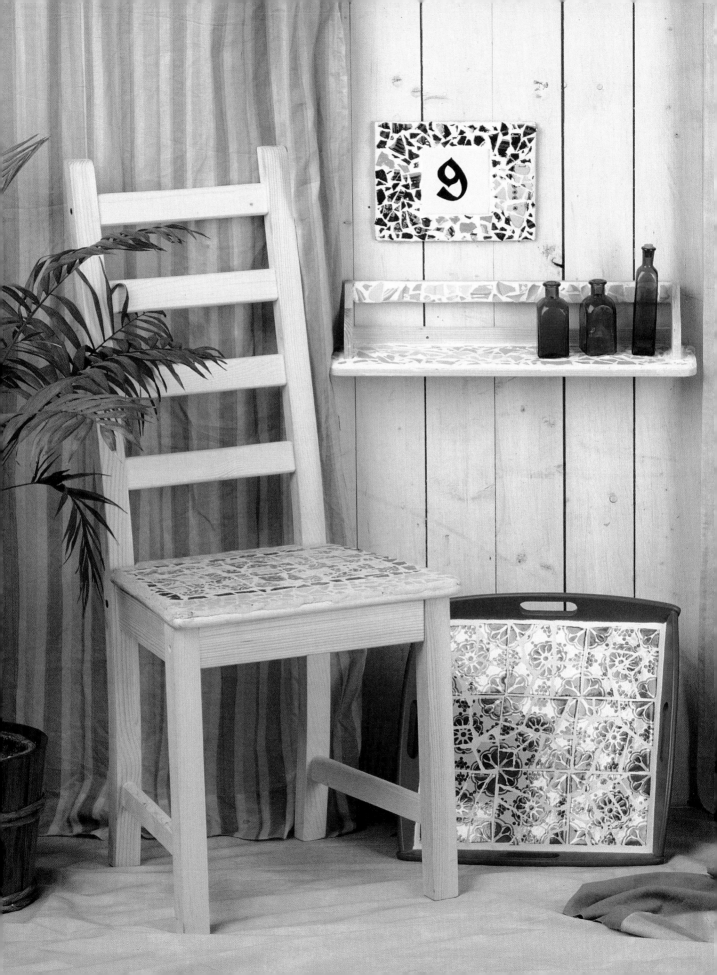

CERAMICS

MATERIALS

In this chapter we are going to deal with mosaic that has been created with ceramics, a material that is to be found in various forms, and always manages to stimulate the imagination.
Numerous types of ceramics are available, from the most common, like plates, to the more sophisticated such as Portuguese tiles, Azulejos.

PLATES: are very easy to find and conveniently priced in all shopping centers, hardware stores or kitchen furniture suppliers. You can find plates in all kinds of shapes and colors or decorated as you like and in numerous styles varying from classical to modern. We suggest that you keep all broken or damaged plates that would otherwise end up in the trash can, as they are a precious raw material for your creations.
CUPS: in the same category as plates, therefore extremely easy to find, in all their versions and colors that you please. Naturally, as with plates, it is a good idea to recycle them; therefore don't throw away all those broken jugs, mugs, cups, milk cups, gravy boats and sugar jars... or anything that has a handle and that would otherwise end up in the trash.
BATHROOM AND KITCHEN TILES: you can look for and find them in all centers that are specialized in ceramics for the home at low cost. Or you could try asking your ceramics dealer if he will give them to you for free: amongst the rejects there will always be some pretty and colored tiles that are ideal for our creations.
AZULEJOS tiles: these are the hardest to find, because not many stores or companies produce or import them from Portugal. For this reason they are also rather expensive: ranging from 6 000 to 10 000 Italian lire each. {convert to dollars}
TERRACOTTA: we have included this common material. You will find a project later on in this chapter where Portuguese ceramic and terra-cotta have been combined giving life to a highly useful and attractive object.

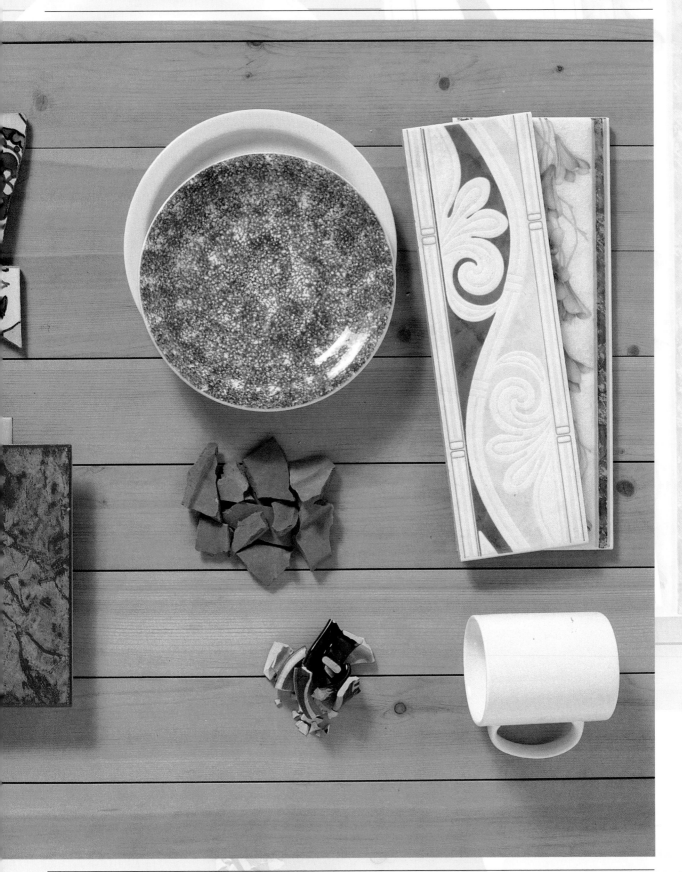

A SUNNY ROW OF AZULEJOS

This tray was made with common assorted and azulejos tiles. It can be used as a decorative object or to serve a fresh drink, at home or outside. The sunny colors chosen for the floral motif make an elegant gift idea and amaze your friends.

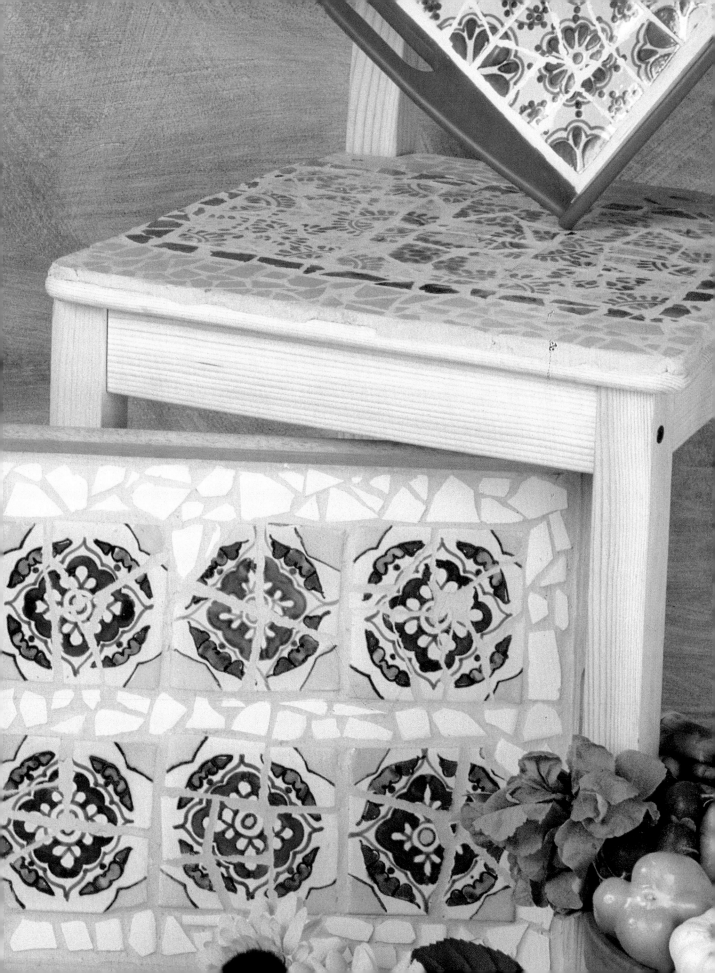

REQUIRED MATERIALS

A RECTANGULAR WOODEN TRAY
A HAMMER
A SPATULA
A PAINTBRUSH WITH FLAT TIP
N. 5
WATER
STICKY TAPE
SANDPAPER
A KITCHEN SPONGE
6 WHITE CERAMIC TILES SIZED
10 X 10 CM
YELLOW CEMENT FOR FILLING IN
THE GAPS
TILE GLUE
8 AZULEJOS TILES
COTTON CLOTH
A SPOON
2 PLASTIC PLATES
ACRYLIC YELLOW COLOR

Position the sticky tape around the inside perimeter of the tray to protect it from the applications of cement and glue.

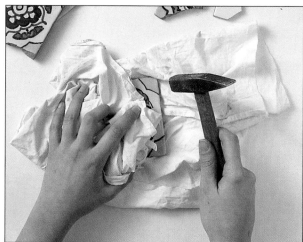

Place a Portuguese tile inside the cloth and break it with a decisive stroke. Then re-arrange the tile in proximity of the tray, ready to use for its decoration.
Now break up the white tiles, in order to obtain small pieces sized about 2 or 3 cm.

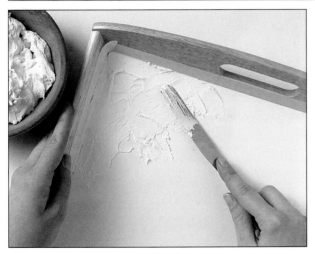

Apply an even layer of the tile glue - max. 4 mm thick - on to the surface of the tray, using the spatula. Level out the surface, again using the spatula. This should be finished very rapidly, before the glue has a chance to dry.

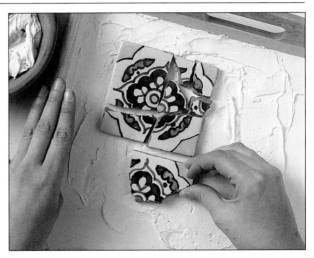

Keeping a distance of about 3 cm from the edge of the tray, reassemble the 8 Portuguese tiles on the tray's surface and with a light pressure adhere them to the layer of glue underneath. As you insert the tiles be sure to leave to a space of 1/2 cm between each one and a space of 1 cm between the two rows of 4 tiles.

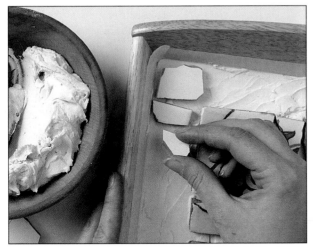

Now arrange the pieces of white tile in a mosaic pattern along the edge of the tray and between the two lines of Portuguese tiles creating a hypothetical frame. Proceed with a sure hand, exercising a light pressure on the tiles. Leave the glue to dry for 30 minutes, so that you can be sure that your work is dry.

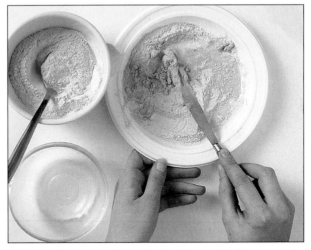

Prepare the cement in a plastic plate and with a spatula mix 10 spoons of yellow cement powder for filling in the gaps. Use 1/2 glass of water, in order to create a soft paste that should be dense but not too liquid. This will be easy to apply and will dry quickly.

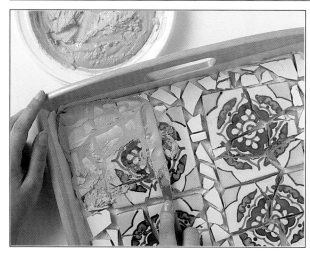 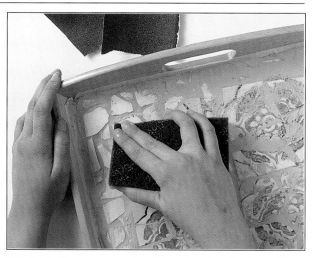

Using the spatula apply the cement on the whole surface of your ornament. You can also use your fingers for filling in the gaps. When you have finished, leave it to dry for about 20 minutes.

Eliminate the excess cement by cleaning the tray with a wet sponge. In this way you will bring your ornament to light without spoiling the cement between the gaps. Proceed carefully with this operation until you have finished cleaning. Pull off the sticky tape on the inside edges of the tray.

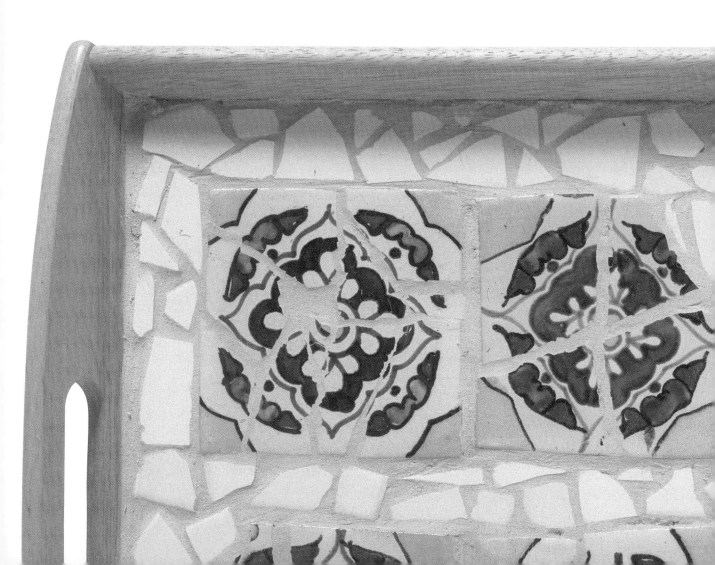

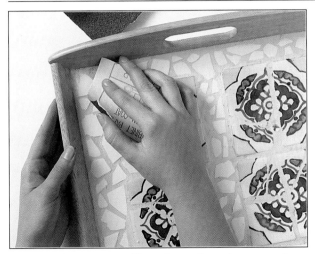

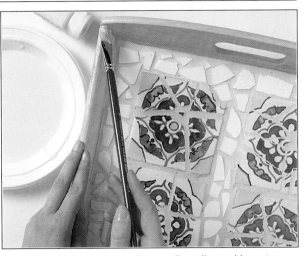

Level out the cement with a piece of sandpaper and remove any encrustations on the tiles. Remember to do this carefully in order not to scratch the surface. Using a dry cloth remove any powder.

Prepare the color mixing the acrylic yellow with water. Using the paintbrush apply the color on to the interior surface of the tray being careful that no color leaks onto the cement.

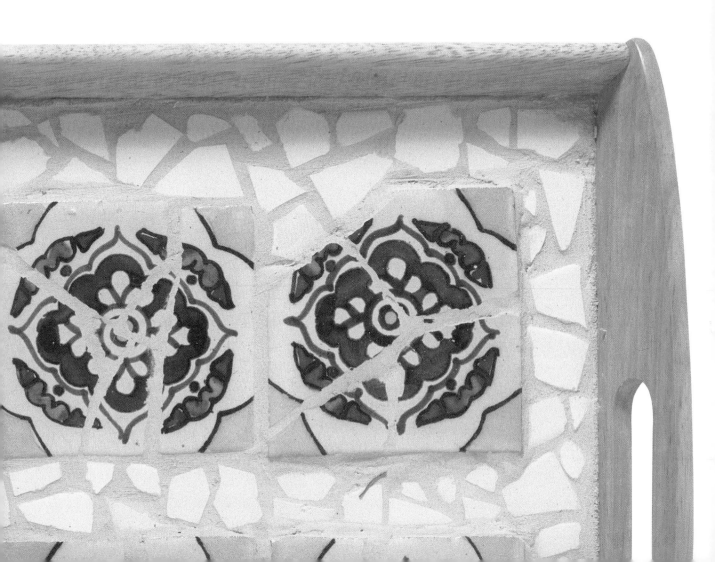

HANGING VASE WITH MOSAIC IN TERRACOTTA

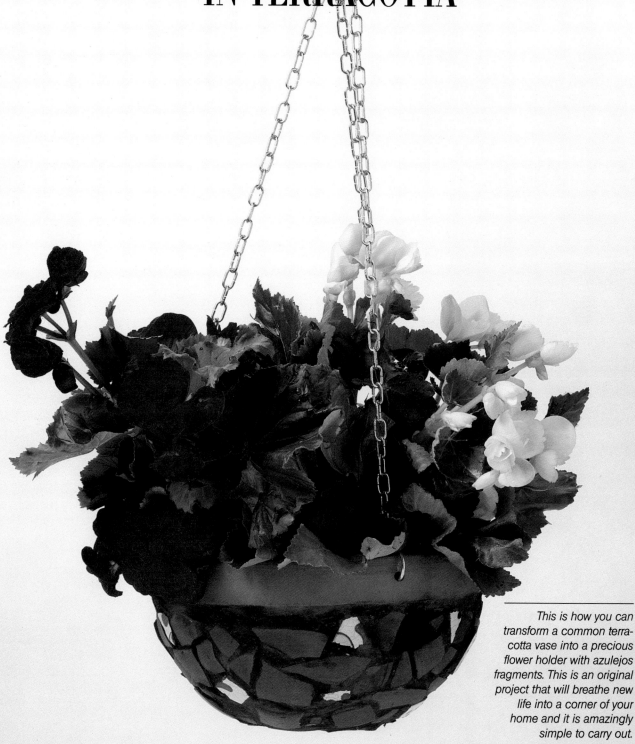

This is how you can transform a common terra-cotta vase into a precious flower holder with azulejos fragments. This is an original project that will breathe new life into a corner of your home and it is amazingly simple to carry out.

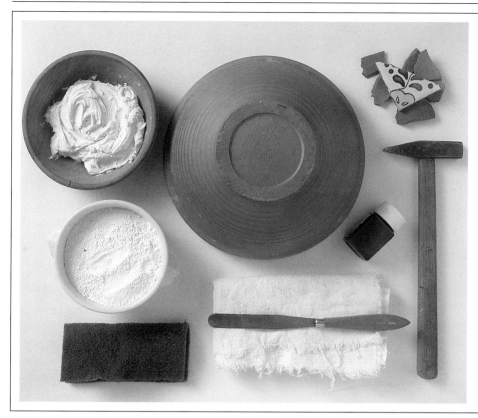

REQUIRED MATERIALS

A HANGING VASE IN TERRA-
COTTA
A HAMMER
BLACK ACRYLIC COLOR
COTTON CLOTH
SPONGE
WATER
SPATULA
WHITE CEMENT FOR FILLING IN
THE GAPS
TILE GLUE
A TERRA-COTTA BOWL
PORTUGUESE AZULEJOS PIECES
FINELY GRAINED SANDPAPER

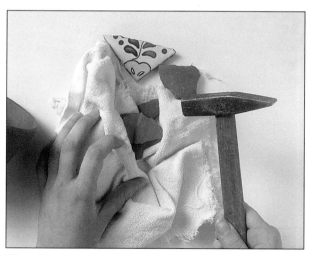

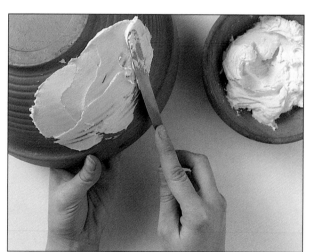

Wrap the terra-cotta vase into a cotton cloth and smash it with the hammer, breaking it with a couple of decisive strikes. Do the same for the azulejos tiles. Make sure that the cloth is well closed to prevent the dangerous flying out of pieces.

Complete the breaking, keep the pieces separate and at arm's reach, to make your task easier. Using the spatula spread the glue over the entire external surface of the hanging vase. The glue should be spread rapidly - so that it does not dry straight away - to a thickness of 4mm.

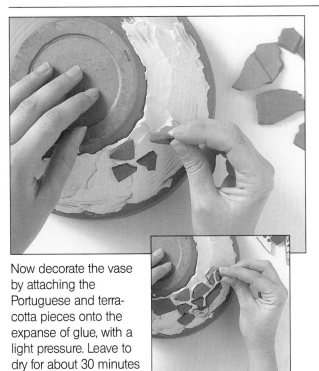

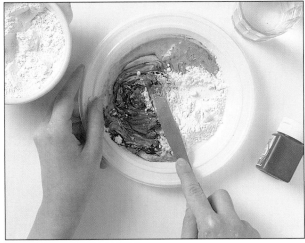

Now decorate the vase by attaching the Portuguese and terra-cotta pieces onto the expanse of glue, with a light pressure. Leave to dry for about 30 minutes until the pieces are firmly fixed.

Prepare the cement mix in a plastic plate by mixing cement powder with water and the acrylic black.. It is important to use the right amount of water for a successful cement mixture, if it is too liquid or too solid it could be difficult to spread. The paste should have a soft consistency that is easy to stir with paintbrush.

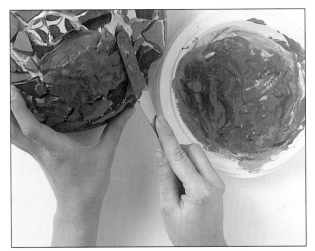

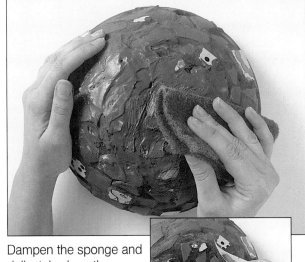

Spread the cement on the entire surface of the mosaic making sure to fill in all the gaps. If you like you can do this using your hands, after having put on a pair of rubber gloves. In this way it will be easier to fill in all the nooks and crannies.

Dampen the sponge and delicately clean the ornament, eliminating any excess cement. Continue in this way until the mosaic has been brought to light. Let the cement dry and then polish your piece of work with the sandpaper.

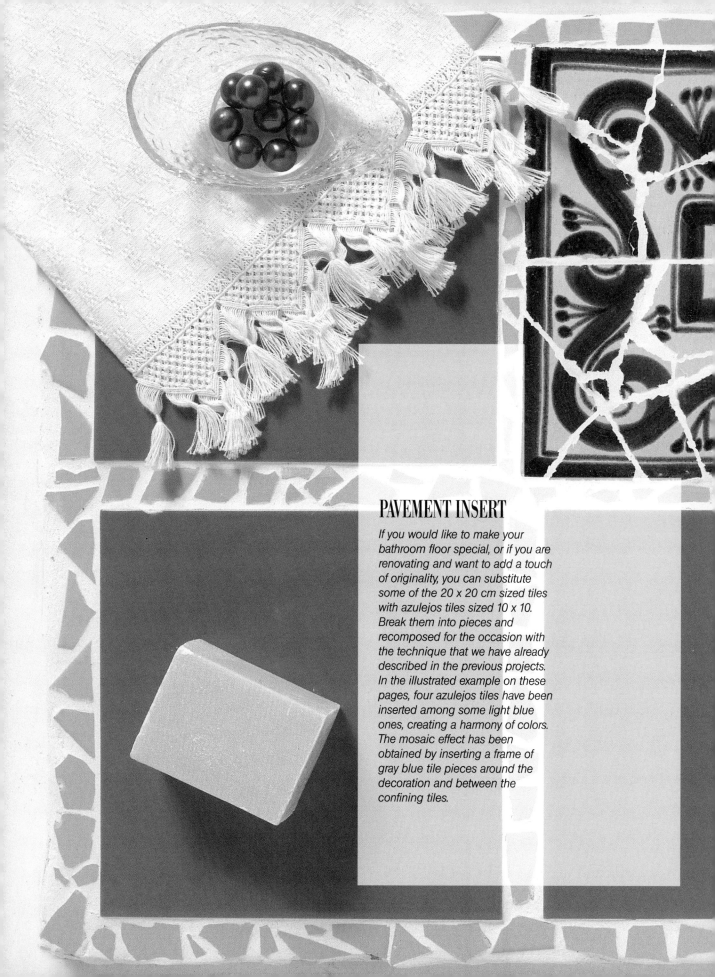

PAVEMENT INSERT

If you would like to make your bathroom floor special, or if you are renovating and want to add a touch of originality, you can substitute some of the 20 x 20 cm sized tiles with azulejos tiles sized 10 x 10. Break them into pieces and recomposed for the occasion with the technique that we have already described in the previous projects. In the illustrated example on these pages, four azulejos tiles have been inserted among some light blue ones, creating a harmony of colors. The mosaic effect has been obtained by inserting a frame of gray blue tile pieces around the decoration and between the confining tiles.

MARINE BEDSIDE TABLE

Made with micro squares of marine colored ceramic and pieces of blue plate, the surface of this table is ideal for those who love marine surfaces. Its creation requires much patience and precision, thanks to which it will be possible to obtain a satisfying result and add a touch of ìnew ageî to your bedroom.

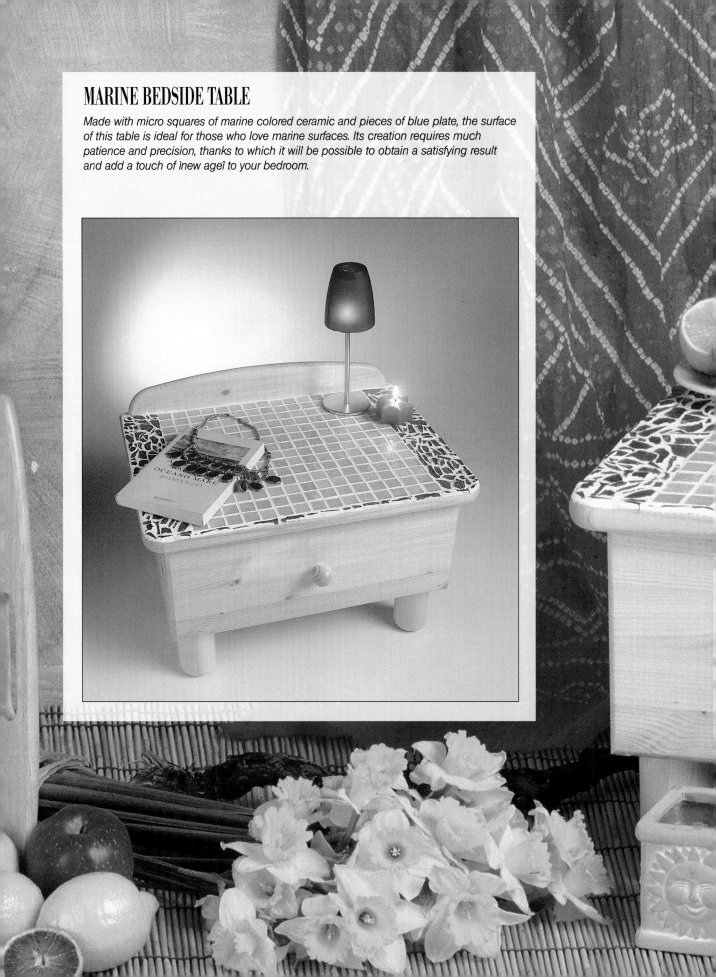

STREET NUMBER SIGN

If you have a cracked mug that you are sentimentally attached to, don't throw it away. This fun street number sign has been made by adding bits of broken mug to the sign, recreating the effigy of the mythical submarine yellow of the Beatles.
With some broken and rearranged tiles. You too can also make a fun and practical house number sign to attach to the entrance gate or by the door of your home.

SHELF WITH PLATE MOSAIC

The same advice given for cracked cups is also valid for broken plates. Keep them for the creation of decorative objects for your home, like this shelf made with mosaic obtained with fragments of yellow and sea green plate that were glued onto a wooden shelf and fixed with white cement.

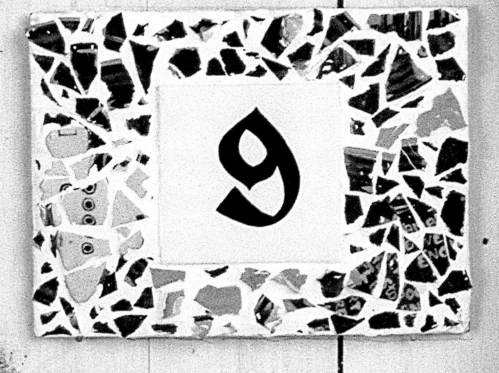

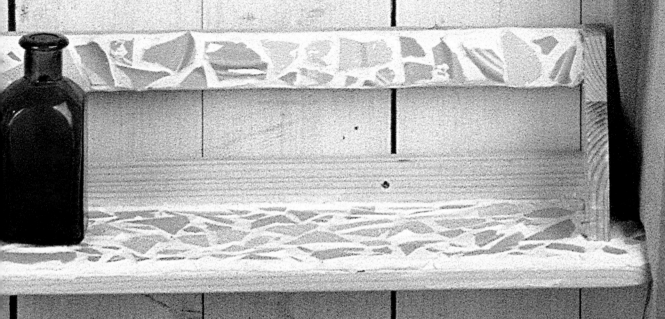

TRAY WITH BLUE AZULEJOS

As an alternative to the project illustrated on page 56, the tray here shown has been made with pieces of blue toned azulejos tiles, recomposed into a mosaic and fixed with white cement. The result is a cheerful and elegant object that is also ideal for serving breakfast in bed.

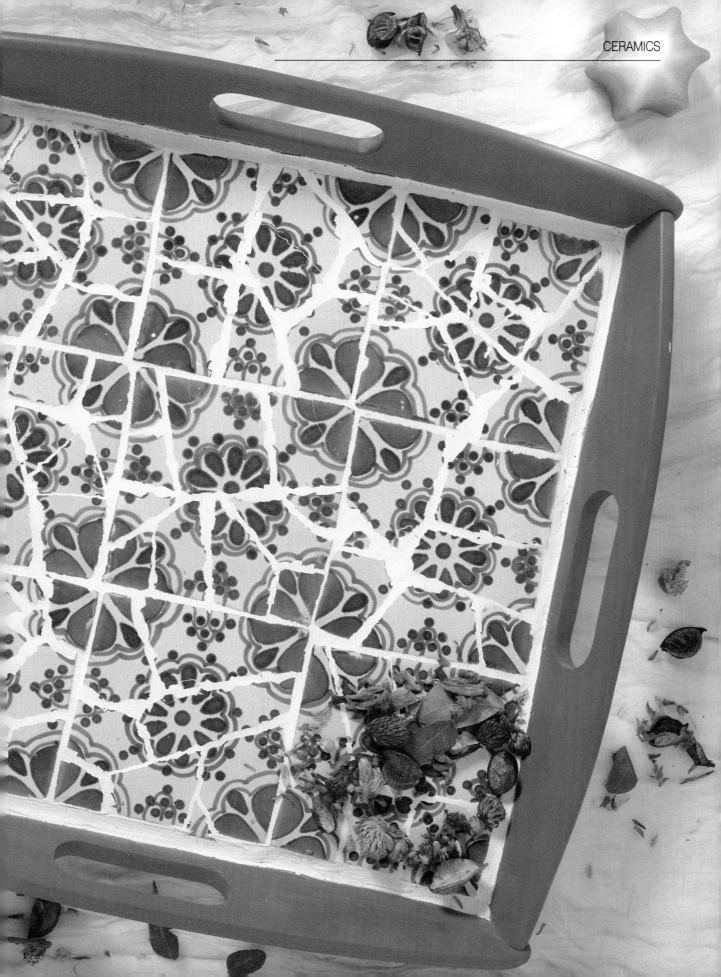

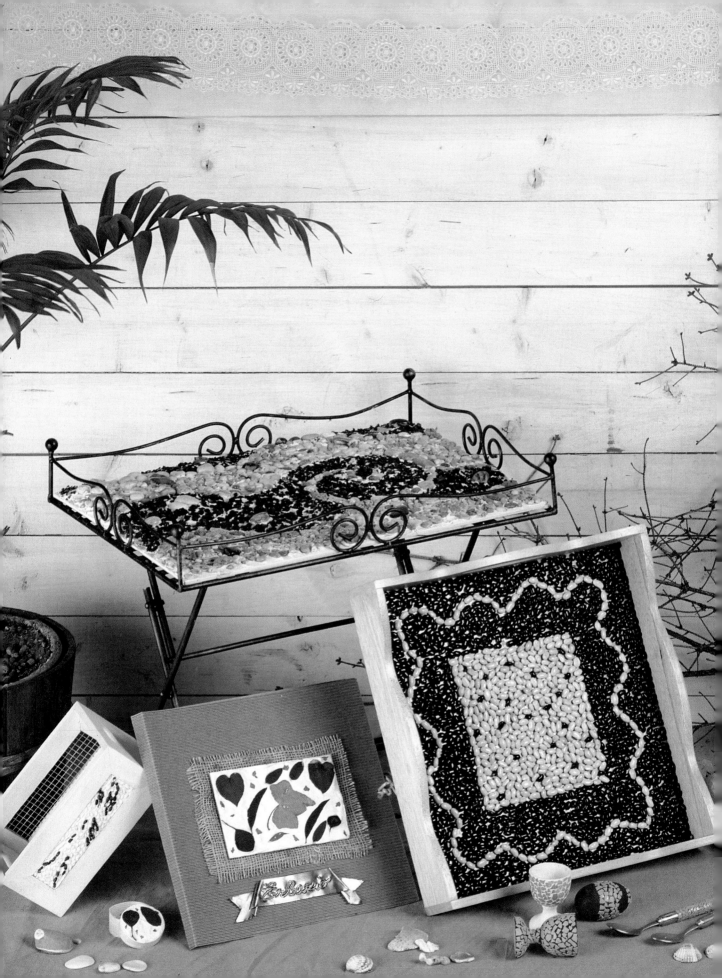

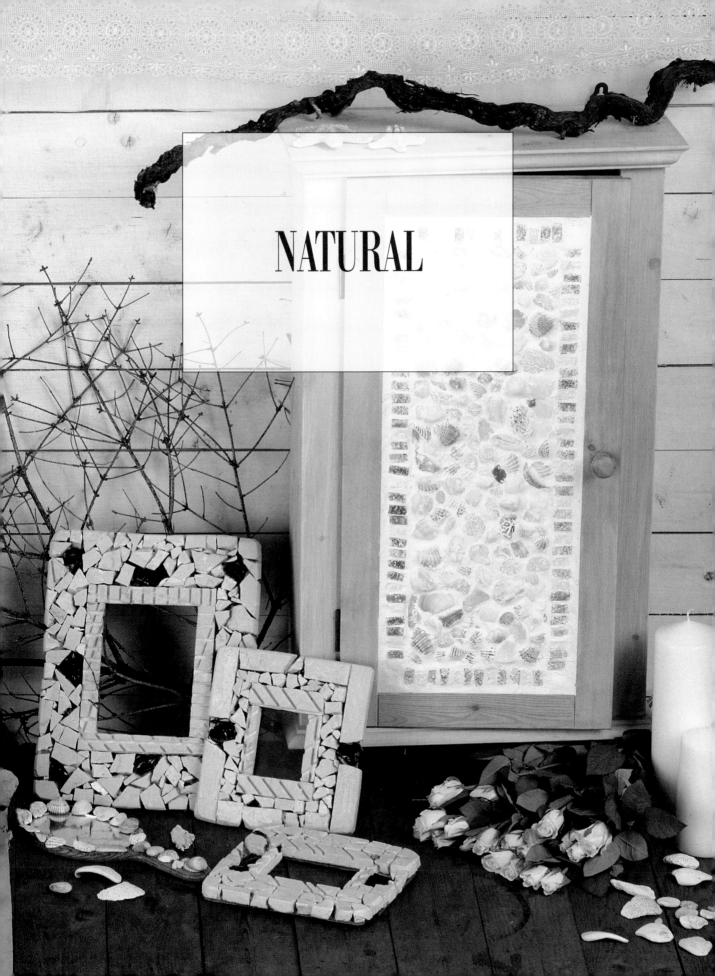

NATURAL

MATERIALS

All that you need to make the objects in this chapter are some simple materials that you can find at home or during nature walks, just pick up all the objects that catch your attention.
Pebbles, grains and cereals, minerals and quartz, fragments of marble, natural and colored rice, egg shells, pressed leaves, pieces of bark, gravel, but also shells, small stones and everything else you find on the sea shore, like fragments of smooth glass, starfish etc. are perfect. All you need to do is look around for a goldmine of materials that can be used in creative mosaic.

GARDEN TABLE

Perfect for breakfast in the garden or out on the terrace, this table with an ethnic flavor has been created with common pebbles. Collect them in two tones choosing stones that have more or less the same size: this will allow you to obtain a uniform result and at the same time to create a decorative table with interesting light shade effects

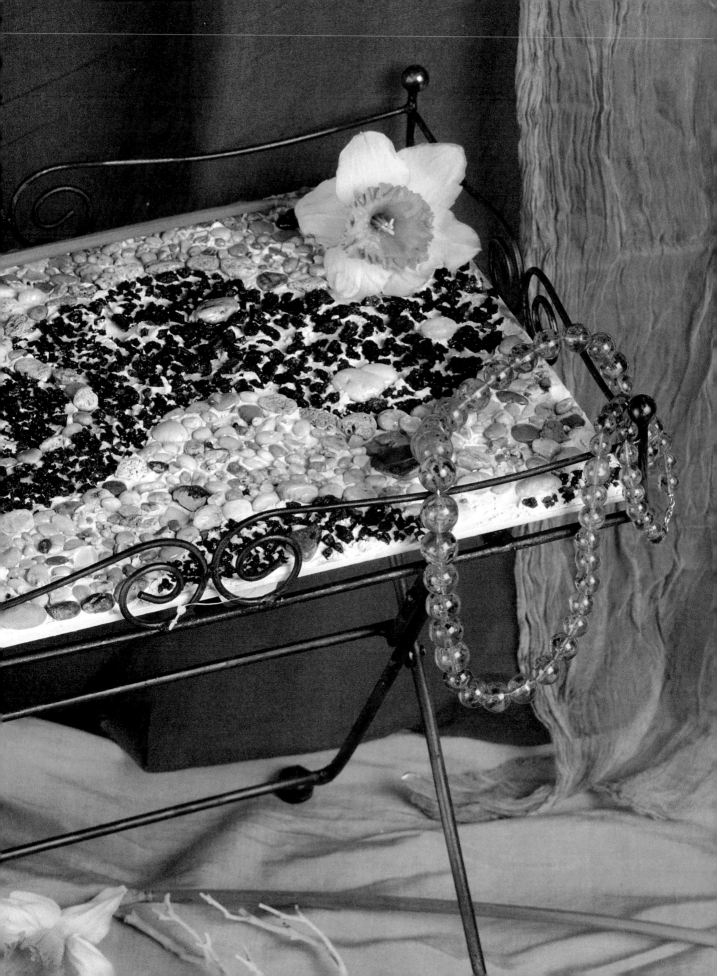

REQUIRED MATERIALS

A WOODEN RECTANGLE
OF 40 x 30 CM
ACRYLIC YELLOW COLOR
VINYL GLUE
CEMENT
A SPATULA
PLENTY OF LIGHT AND DARK
COLORED PEBBLES
A PAINTBRUSH
A PENCIL
FLATTING

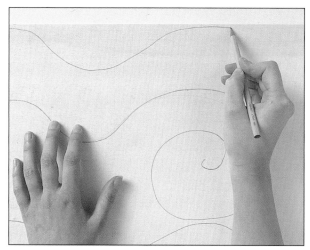

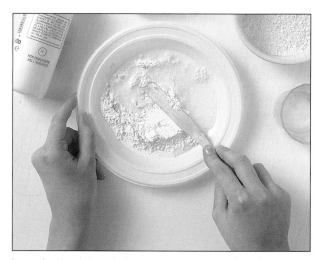

Draw the design or pattern you want to create free hand on the wooden rectangle. It is not important if the outline is not precise: its purpose is to give you orientation as you proceed with the mosaic.
If you prefer you can draw on the wooden rectangle any drawing you like, found in a magazine or elsewhere.

In a plastic plate mix three parts of cement mixture and one part water, to obtain a dense and not too liquid paste. Mix thoroughly until all lumps have been eliminated; incorporate two or three spoons of vinyl glue and the acrylic yellow color in proportion to the intensity you want to achieve. Remember that cement, once dry, tends to lighten.

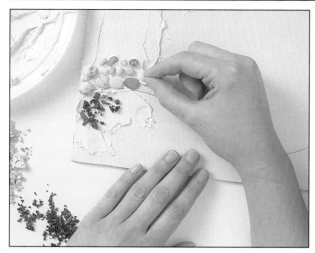

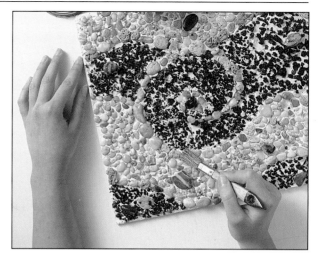

Using the spatula, spread the cement onto a part of the drawing. Work with small areas at a time without the risk of the cement mixture drying too fast. Begin by applying the lighter shaded stones, placing them along the edges first and then on the internal part of the drawing. Alternate different sized pebbles in order to give more movement to the mosaic. Make sure that the pebbles are well inserted into the cement. Proceed in the same way for the darker pebbles.

After you have finished leave the table to dry far from sources of heat that would provoke cracks to the mosaic. Finish off the work by applying a generous hand of flatting to the table's surface, thus making it waterproof, making sure to fill in all the gaps between the pebbles.

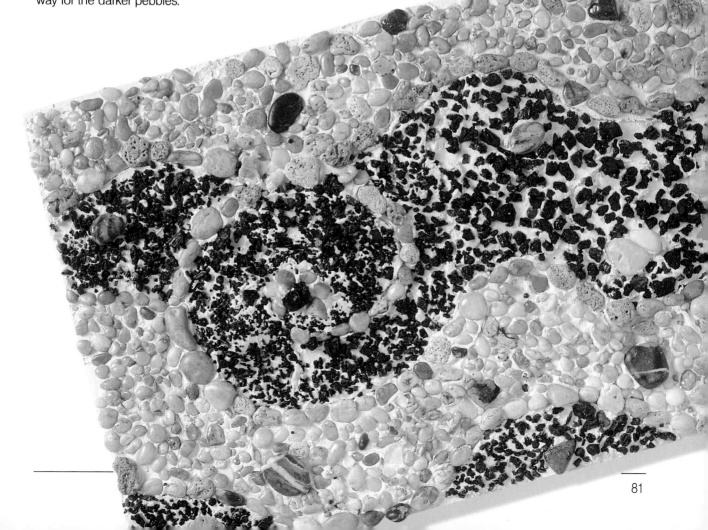

WARDROBE DOORS LIKE ANCIENT ROADS

Shells, stones, fragments of marble and pottery, expertly arranged, give life to a mosaic that transforms your wardrobe door into a piece of ancient road.

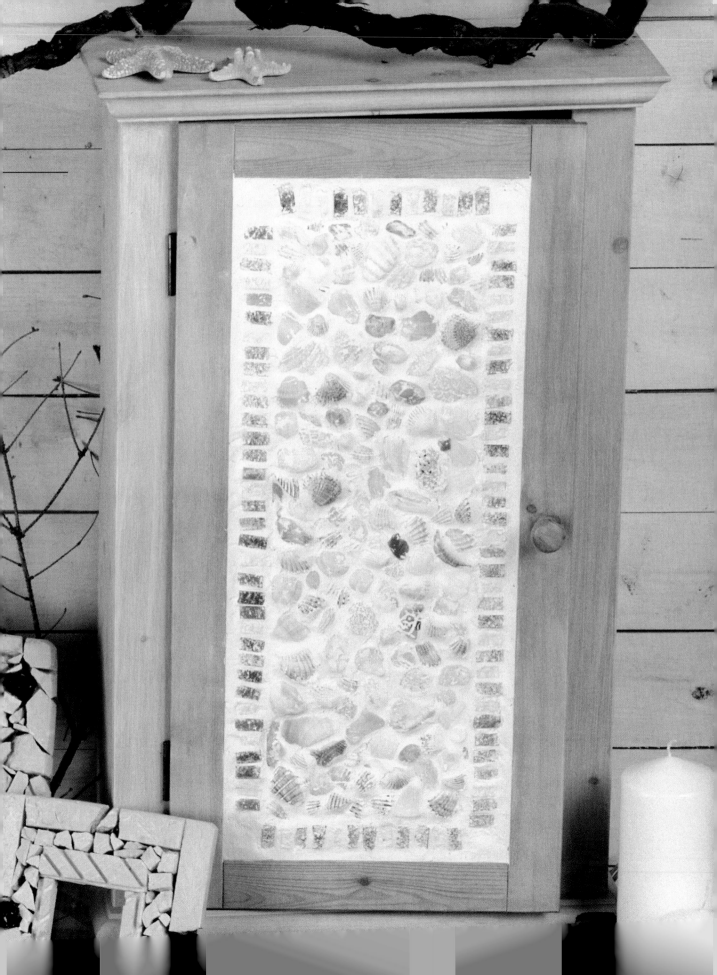

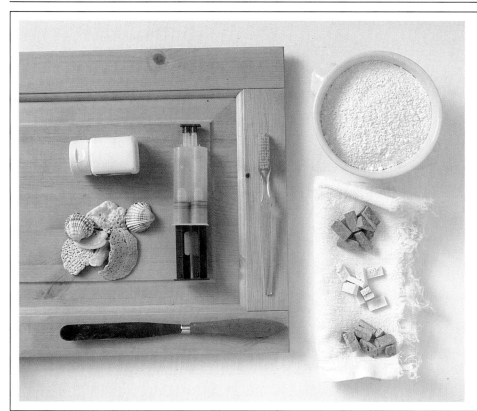

REQUIRED MATERIALS

Two component epoxy glue
Shells
Terracotta fragments
Marble squares
A cotton cloth
White acrylic color
A toothbrush
A spatula
Cement powder
A wooden wardrobe door,
which will be transformed
into a mosaic

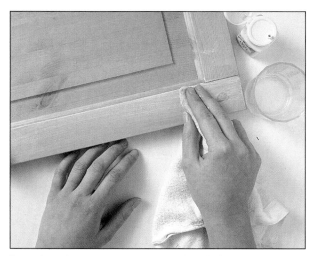

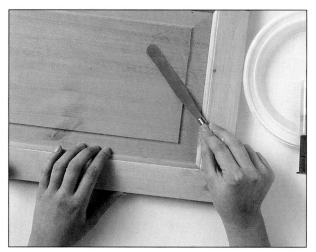

Pour the white acrylic color onto the cloth and rub it into the wooden door in order to obtain a transparent and uneven effect. Concentrate above all on the corners and along the edges. Whenever the color should be dense, remove the excess acrylic with a dampened sponge patting it on the color before drying.
This whitening technique is supposed to "age" the door.

Squeeze the two component glue into a plastic plate and stir with the spatula. In order to complete the composition of the mosaic at ease and without hurry you should always use fresh glue during the adhesion of the elements. Therefore, work on small areas at a time.

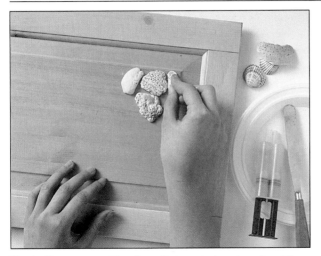

Begin the composition from the central rectangle of the door, or in any case keeping yourself a couple a centimeters from the edge. Alternate shells and the various fragments and work on small areas at a time until you have covered the entire surface.

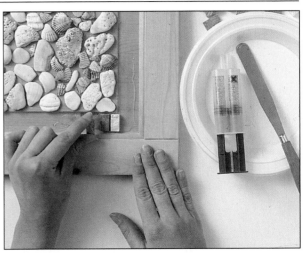

Complete the decoration by applying the glue onto the edges of the door, using pieces of different colored marble. Alternate different shades of color in the fragments to give more movement to the composition.

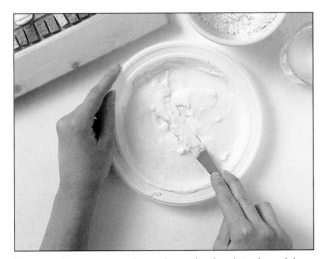

Prepare the cement mixture in a plastic plate, by mixing three parts cement powder with one part water. Stir well in order to eliminate any lumps and to obtain a rather dense mixture; adding more water or cement powder if required.

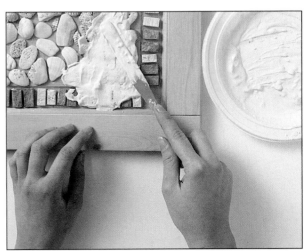

Begin to spread the cement onto the mosaic, working on small areas at a time and being careful to fill in at depth all the gaps between the various fragments. Proceed in this way until the whole surface has been covered and leave it to dry.

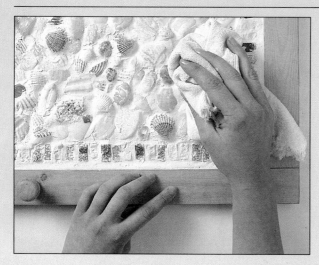

Remove the excess cement with a dry cloth. The result will be better if you do this when the cement has not dried completely. Scratch the surfaces that you can't reach with the cloth with a dampened toothbrush, keeping it continuously clean by soaking it in water and cleaning with a cloth.

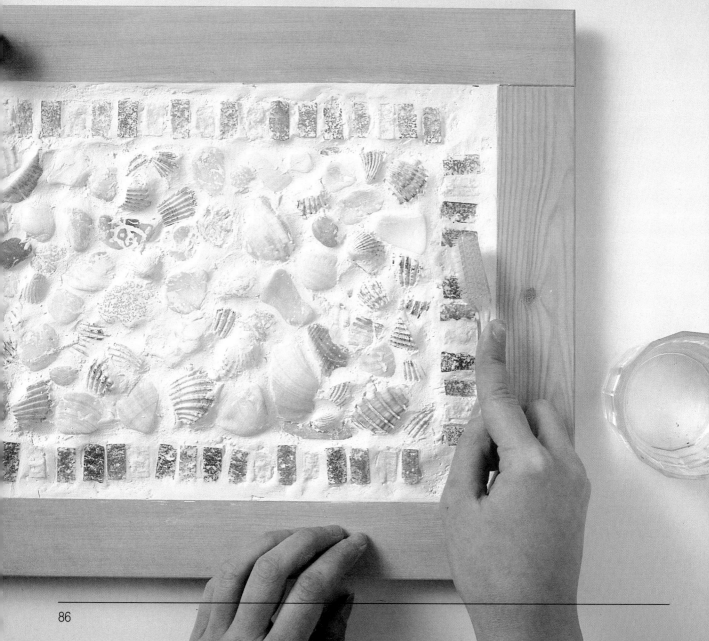

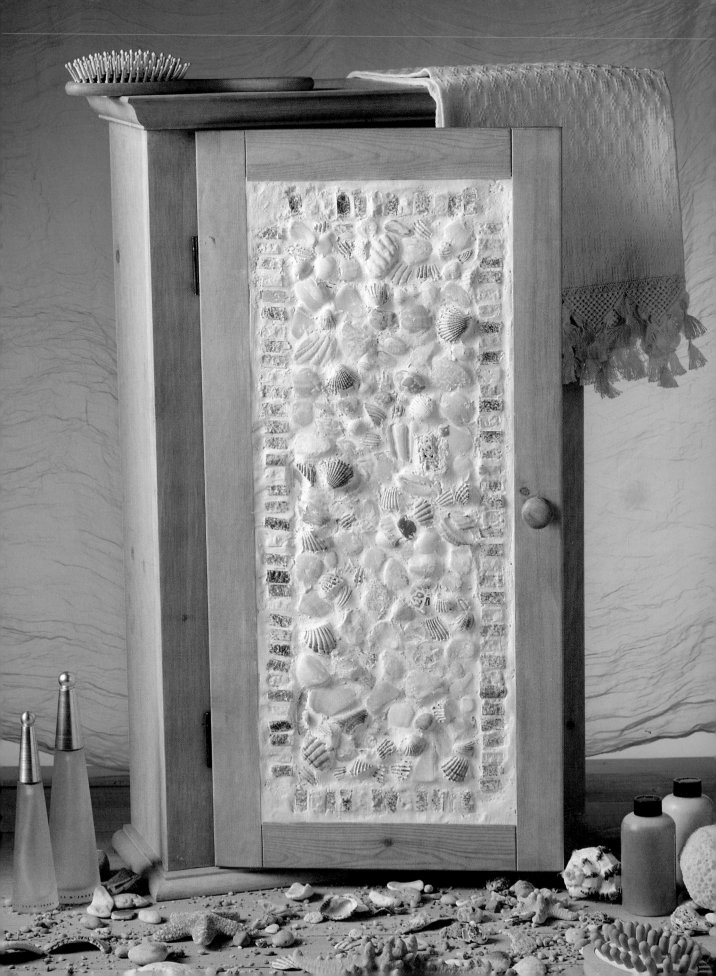

SPOONS WITH EGG SHELLS

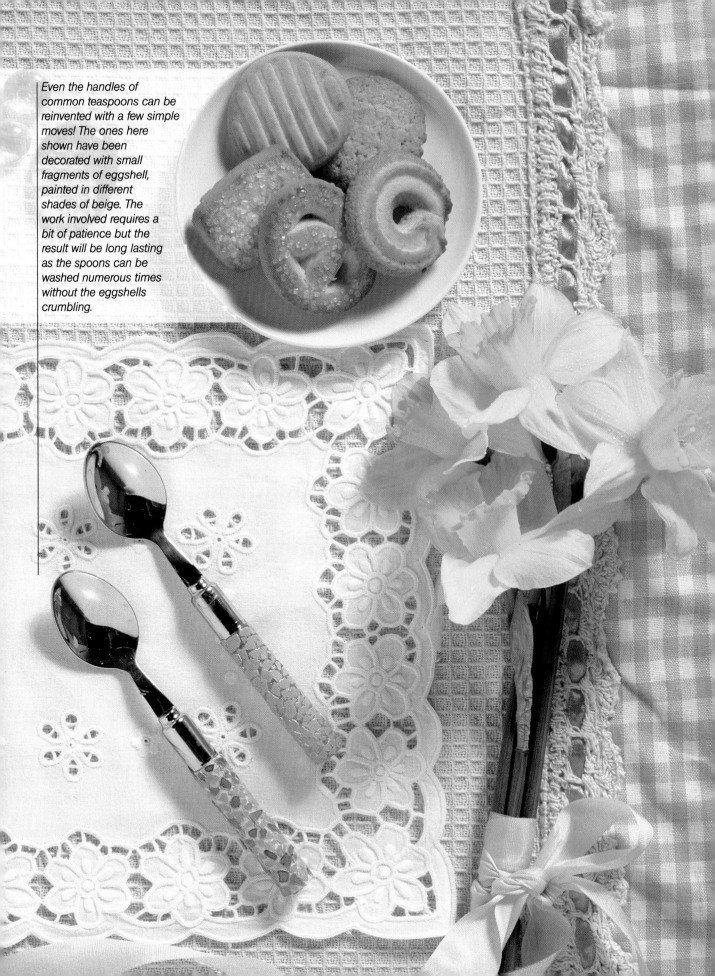

Even the handles of common teaspoons can be reinvented with a few simple moves! The ones here shown have been decorated with small fragments of eggshell, painted in different shades of beige. The work involved requires a bit of patience but the result will be long lasting as the spoons can be washed numerous times without the eggshells crumbling.

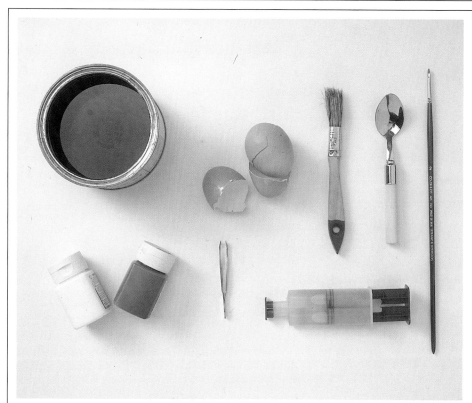

REQUIRED MATERIALS

SOME EGGSHELLS
EYEBROW TWEEZERS
TEA SPOONS
ACRYLIC NUT COLOR
TWO COMPONENT EPOXY GLUE
FLATTING
A PAINTBRUSH

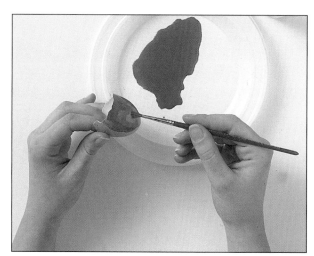

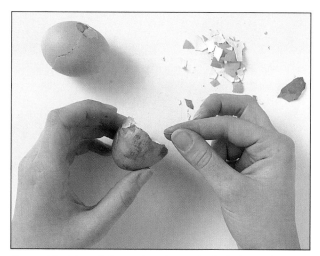

Prepare the acrylic color by diluting a small quantity with varying amounts of water, so that you get two or three shades of beige. Paint the egg shells (that have previously been washed and dried) with the paintbrush, and leave them to dry in a safe place.

Once dried, break the colored eggshells in lots of small pieces. Also break a shell that has not been colored.

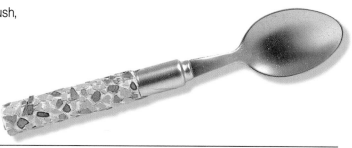

Pour the two component glue into a plastic plate and stir. Spread it on a portion of the spoon's handle using the paintbrush.

Start arranging the bits of eggshell on the handle in the most compact way as possible, taking care not to dirty your hands.

Apply the smaller pieces with the tweezers, trying to cover as much of the surface as possible. For a more accurate result you can cut the pieces to measure. Alternate colored and natural pieces of eggshell. When you have finished, leave the spoon to dry.

When the handle is completely dry, apply a coat of flatting and wait for it to dry.

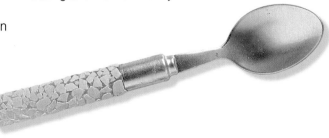

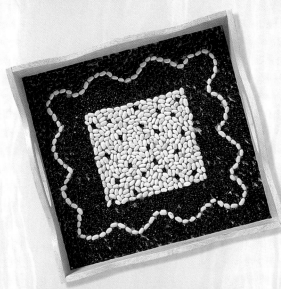

SEEDS AND MARBLE FRAGMENTS

The wooden tray shown here has been made by arranging sticking beans of two contrasting colors onto its base, following a pattern that was penciled in previously. A generous coat of flatting will help to protect your work.

Elegant picture frames can be made by bringing together pieces of marble, and fragments of green glass. In this case, cement has not been applied in order to give the objects a certain lightness.

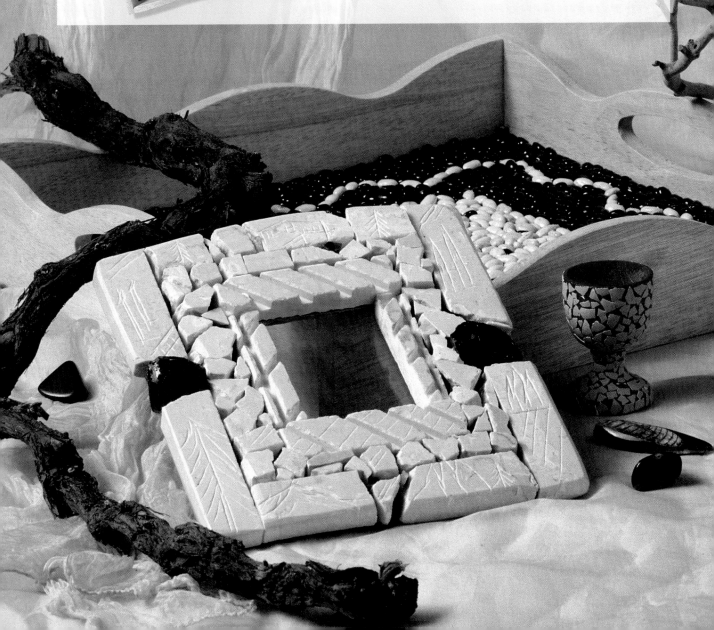

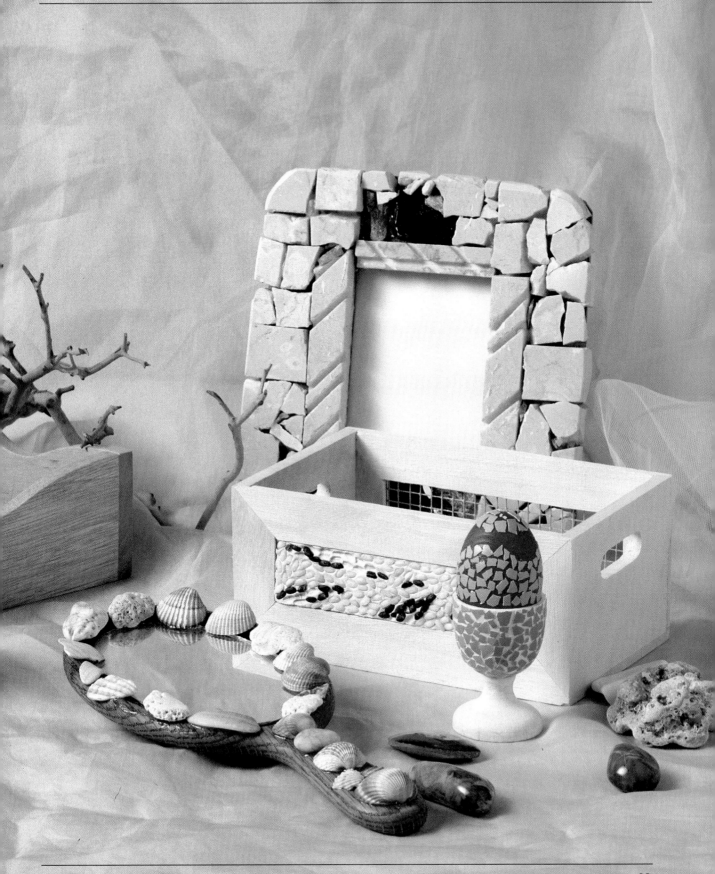

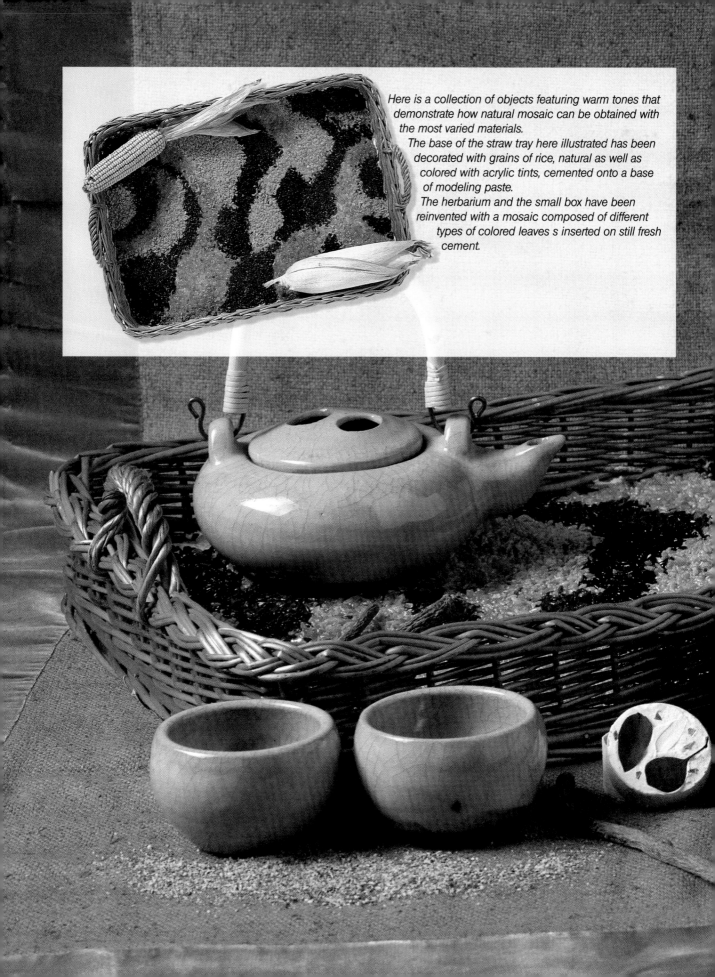

Here is a collection of objects featuring warm tones that demonstrate how natural mosaic can be obtained with the most varied materials.

The base of the straw tray here illustrated has been decorated with grains of rice, natural as well as colored with acrylic tints, cemented onto a base of modeling paste.

The herbarium and the small box have been reinvented with a mosaic composed of different types of colored leaves s inserted on still fresh cement.

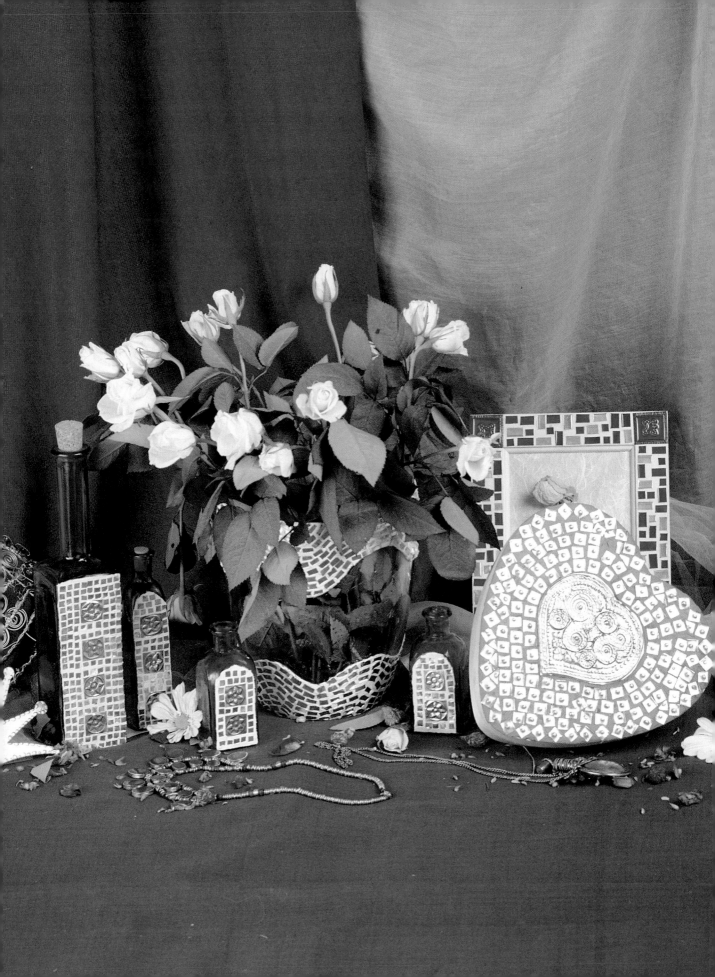

METAL

MATERIALS

EMBOSSING OR SHEET METAL: this material is available in color supply or fine crafts stores and is sold in fine sheets of varying sizes and in the colors aluminum, copper, red, green and blue. It is easy to cut with scissors or cutters and is therefore ideal for creative projects.

EMBOSSED METAL: embossing involves a technique using different instruments, enabling you to create embossed pieces of work on thin layers of metal. This is done by putting the sheet metal on a soft surface (a mouse pad or cloth for example) so as not to ruin the supporting surface, and pressing down with a pointed but not too sharp instrument. This delicate technique allows the realization of very elaborate adornments. Since we are dealing with ìtenderî {I think that it is supposed to say tender, but that doesn't make much sense with the sentence. Metal is not tender.} metal common household objects, such as a pen to a toothpick, are suitable for embossing.

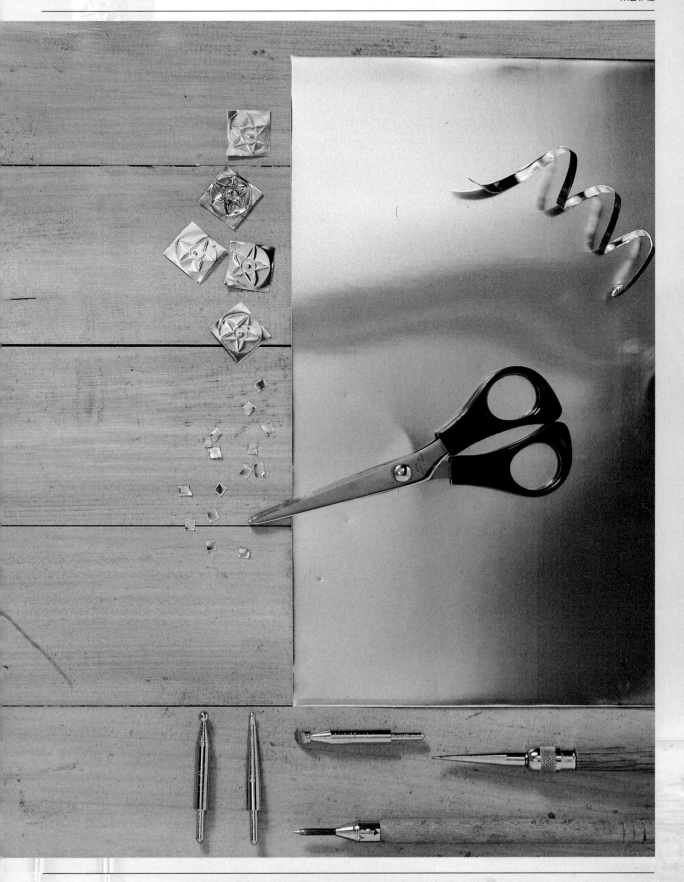

VASE WITH ARGENTINIAN WAVE

Metal mosaic is a technique that can beautify even the simplest objects like this glass vase with variations on light. To create an interesting contrast only the central part of the vase has been left undecorated, allowing us to see inside. Both elaborated parts of the vase are the same size, creating an appearance of harmonious uniformity. Furthermore, an undulating pattern was chosen to bring life to the object.
Effects that are just as interesting can be achieved by geometric decorations, floral or decisively abstract.

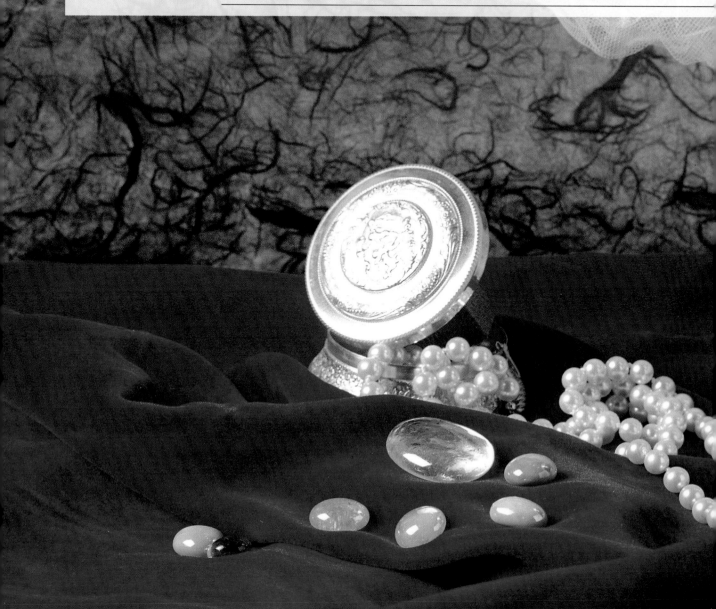

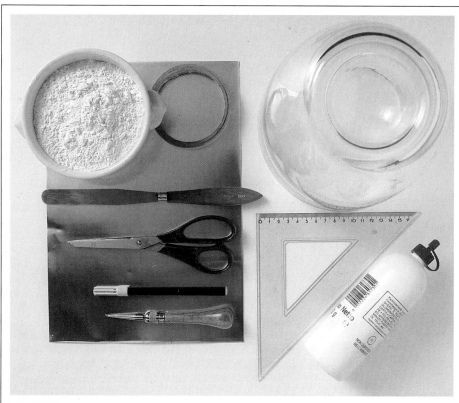

REQUIRED MATERIALS

A GLASS VASE
SCISSORS
CEMENT POWDER
VINYL GLUE
A SHEET OF SILVER-PLATED METAL
A POINTED OBJECT FOR EMBOSSING
A SPATULA
WASHABLE PEN
TRIANGLE
STICKY TAPE

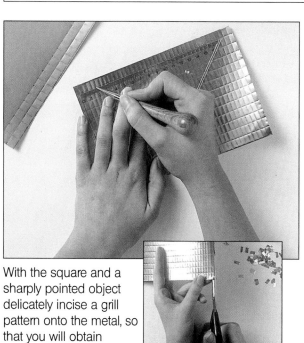

With the square and a sharply pointed object delicately incise a grill pattern onto the metal, so that you will obtain rectangles sized 1 x 0.5 cm. Cut out the rectangles with a pair of well sharpened scissors, making sure a the edges are well squared.

Trace two undulations on the vase with the pen that will act as the border to your mosaic. Fasten the sticky tape around the edges in order to cover the parts you will work on and to keep it clean.

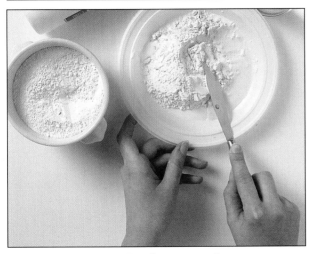

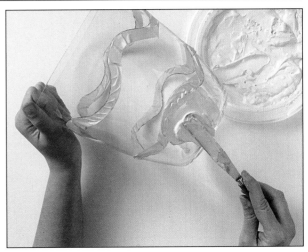

Prepare the right quantity of cement, using as a guideline, one part water mixed with three parts cement. Stir accurately to avoid the formations of lumps. Add a few spoonfuls of vinyl glue to obtain a homogeneous compound that will not crack at end of your work.

Spread some of the cement onto a small part of the surface to be decorated. If you work on small areas at a time, you will always be operating on fresh cement. At this stage, bits of cement could spill over onto the adhesive tape: it does not matter, so long the sticky tape does not get covered completely.

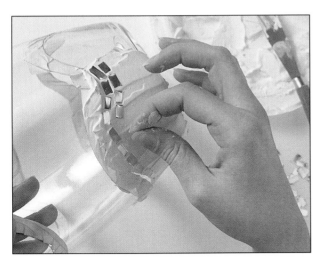

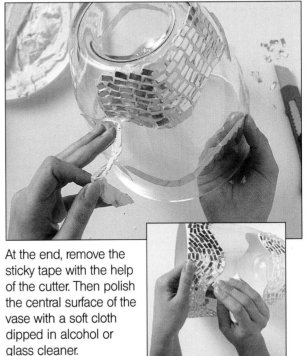

Begin arranging the metal squares by pressing them gently onto the cement, without sinking them in. Carry on following the line of the sticky tape and trying to be as neat and regular as possible. Continue until you have covered the entire stretch of cement.

At the end, remove the sticky tape with the help of the cutter. Then polish the central surface of the vase with a soft cloth dipped in alcohol or glass cleaner.

EMBOSSED METAL ON BLUE GLASS

Glass, particularly when colored, is very suitable for decoration using the embossed metal technique. In these pages we propose a series of blue bottles, of various dimensions, that have been adorned with a central decoration and have quite an antique appearance and are simple to make.

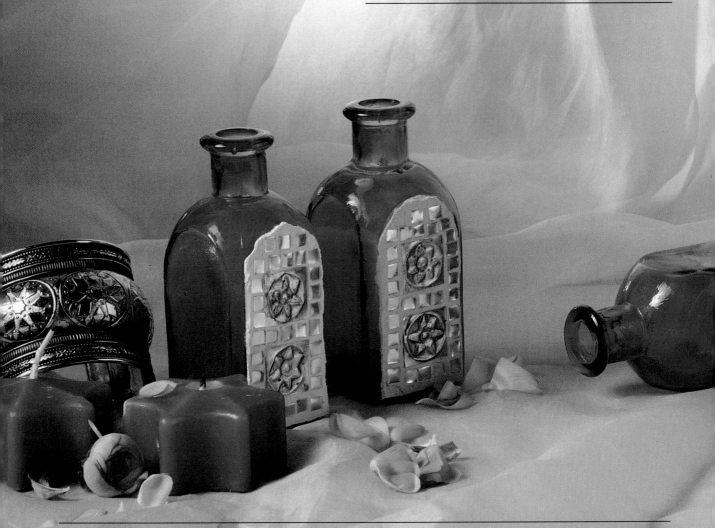

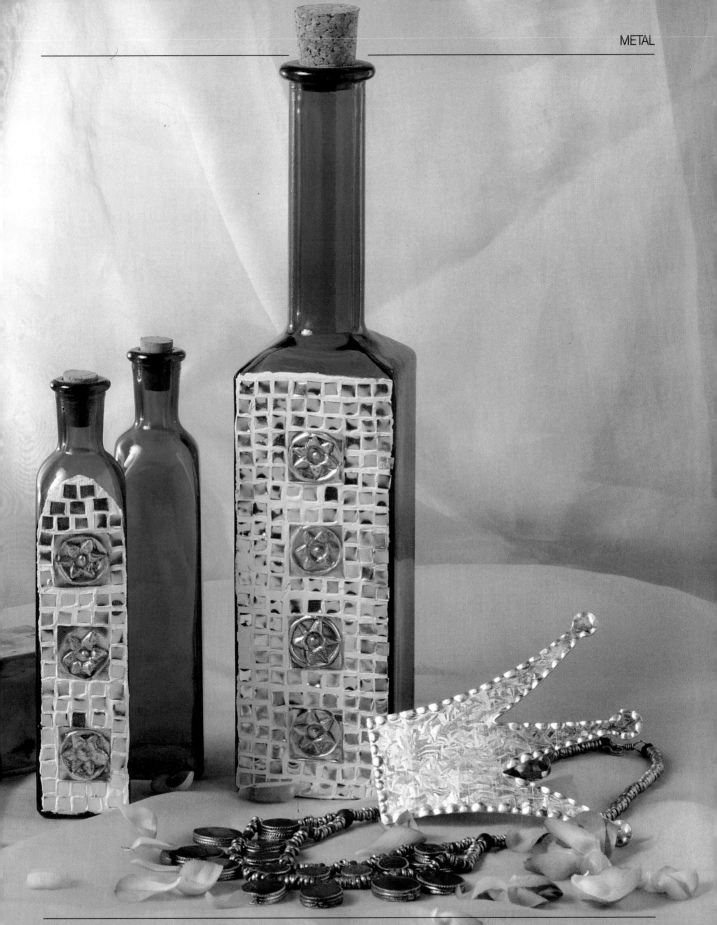

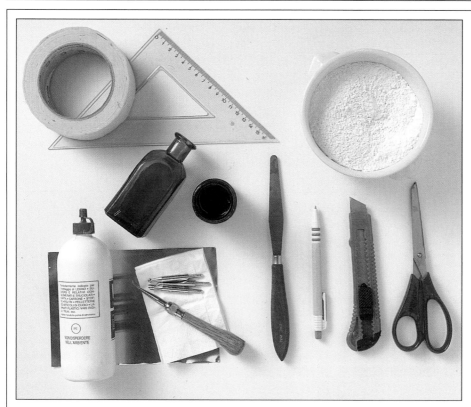

REQUIRED MATERIALS

BLUE GLASS BOTTLES
CEMENT POWDER
A SHEET OF SILVER-PLATED
METAL
SHOE POLISH
COTTON CLOTH
VINYL GLUE
FINELY POINTED METAL OBJECT
FOR EMBELLISHING
SCISSORS
STICKY TAPE
A CUTTER
A SQUARE
A SPATULA

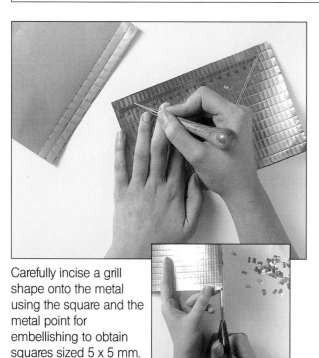

Carefully incise a grill shape onto the metal using the square and the metal point for embellishing to obtain squares sized 5 x 5 mm. Cut them with out with well sharpened scissors.

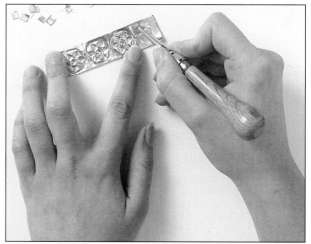

Draw small suns on another metal sheet with a light but visible pressure. Lean on a soft surface and using the metal point start to emboss the first sun. Very gently and by degrees, beginning first of all with a light pressure and increase as you go along until the drawing appears evident and well marked. Proceed in the same way for the other suns.

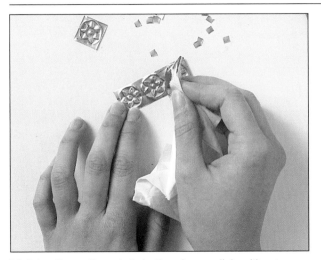

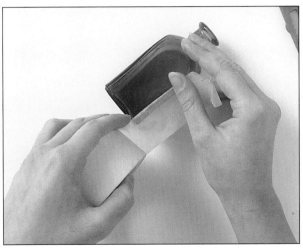

Moisten the cotton cloth in the shoe polish without exceeding the amount, if this happens you can pass the unwanted color onto a paper towel.
Pass the cloth quickly and gently on the embossed part: the color will deposit itself on the edges of the drawing, giving them an antique look. Leave to dry; and then cut out the sun shapes with a pair of scissors.

Cover up the edges of the bottle that you want to decorate with the sticky tape. You can use the cutter to help you.

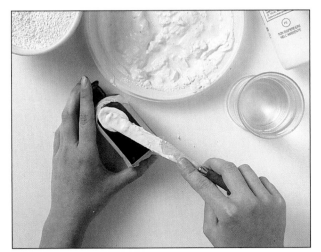

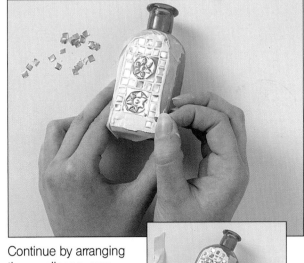

Mix together one part water, one part vinyl glue and three parts white cement powder in a plastic plate. Stir well to obtain a smooth mixture without any lumps. Apply a light layer of cement with the spatula on the bottle's surface. Start arranging the larger metal squares.

Continue by arranging the smaller squares, being careful not to let them sink into the cement nor to let them float on it. Leave the bottle to dry and remove the sticky tape.

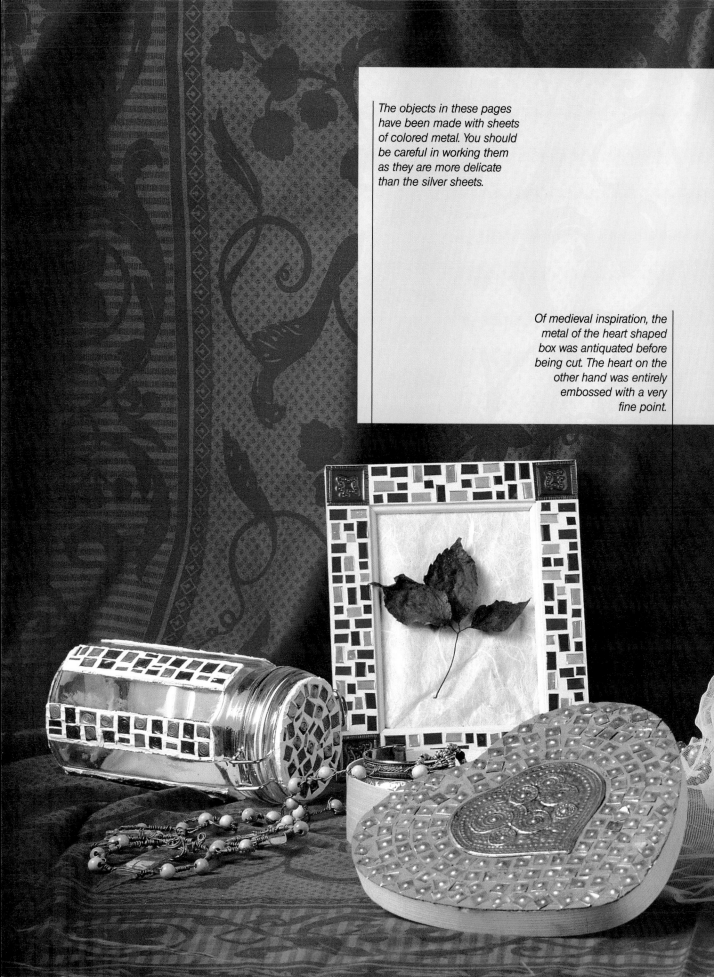

The objects in these pages
have been made with sheets
of colored metal. You should
be careful in working them
as they are more delicate
than the silver sheets.

Of medieval inspiration, the
metal of the heart shaped
box was antiquated before
being cut. The heart on the
other hand was entirely
embossed with a very
fine point.

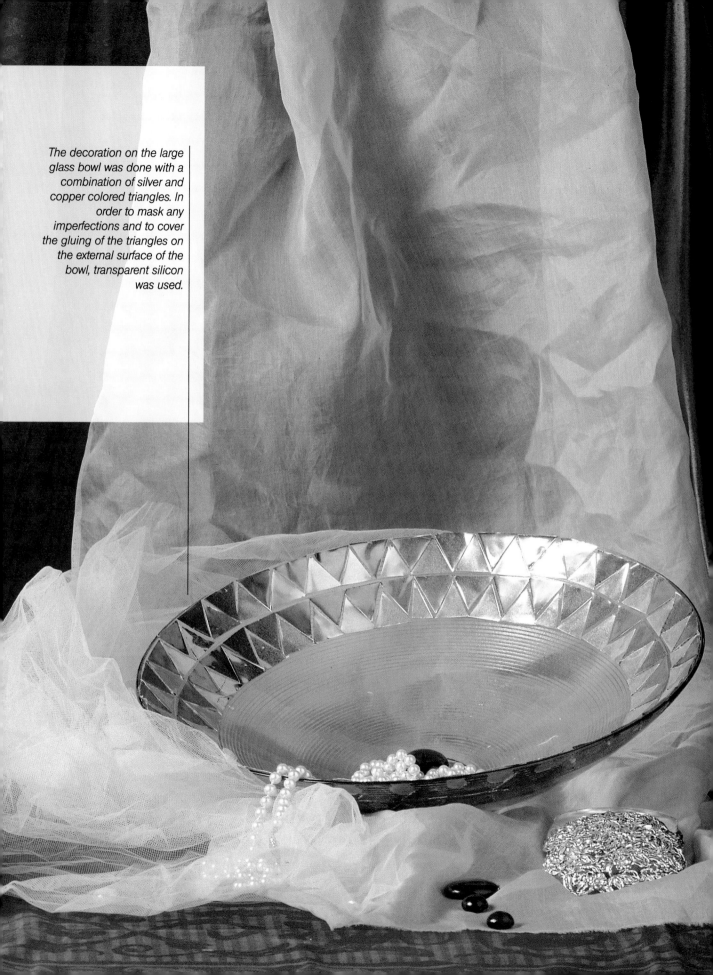

The decoration on the large glass bowl was done with a combination of silver and copper colored triangles. In order to mask any imperfections and to cover the gluing of the triangles on the external surface of the bowl, transparent silicon was used.

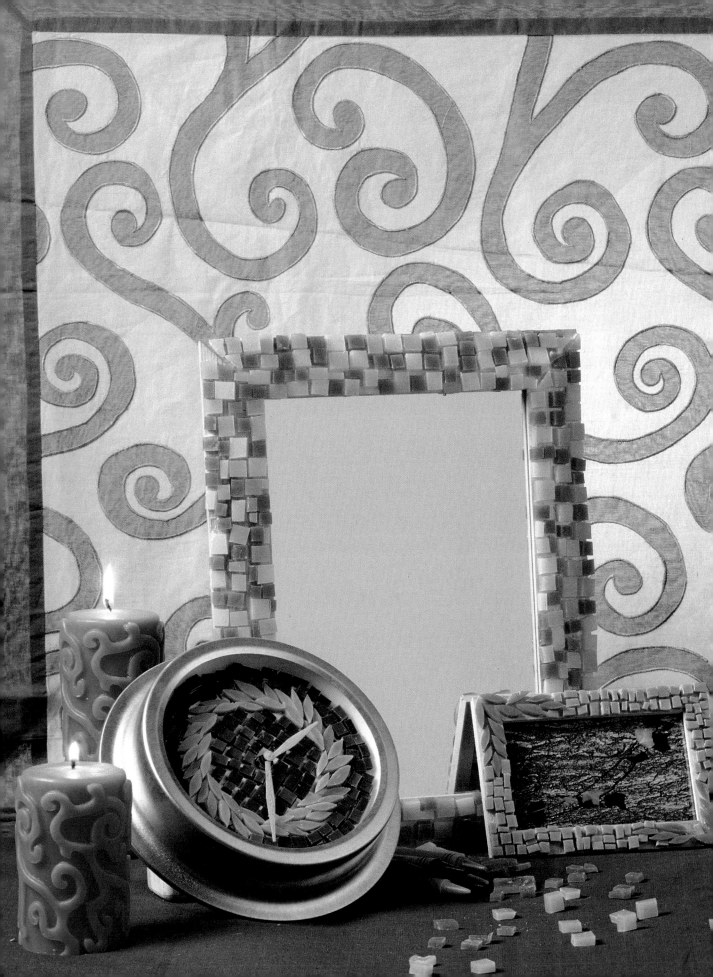

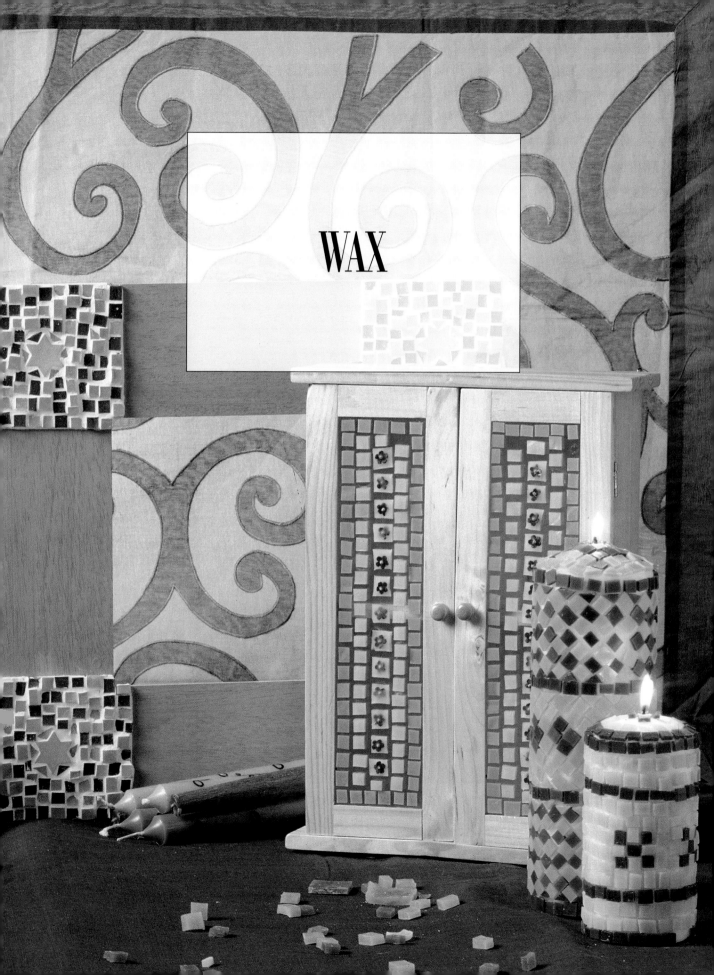

WAX

MATERIALS

GENERAL NOTE: wax is suitable for numerous applications although it requires some small tricks in the course of its manufacture.
It should always be melted into a pan using the bain-marie technique at a medium to low flame and never in direct contact with the flame because wax is flammable. It should be kept at a consistent temperature throughout its workmanship
Always use a clean pan.
At the end of your work, remove the residue wax by melting it and removing it with tissue paper.

CANDLES: ordinary candles are widely available in supermarkets and household stores. They are cheap, available in a vast range of colors and are ideal for melting and reassembling with creativity. Once the candle is liquefied, remember to remove the wick.

WAX IN PIECES: white or colored, and available in specialized or DIY stores. Available in packets of 1/2 there were a lot of these. Please fill in the correct measurement wherever an omega is shown. Thanks or 1 kg, in handy plastic bags, that allow you a precise dosage and to avoid waste.

WAX CRAYONS: are ideal for melting together with white candles or pieces of wax to obtain infinite chromatic shades.

COLORED CANDELS: do not need to be mixed with the wax crayons for color. However be careful when buying candles: some of them have been colored only on the surface and once melted down, will give you only white wax.

PERFUMED CANDLES: usually used to diffuse particular essences, scented candles can be utilized for the realization of mosaic candles to give a perfumed touch to your work.

PERFUMED ESSENCES: available in fine art and specialized stores, to be added in small doses to unperfumed wax during the burning of the candle.

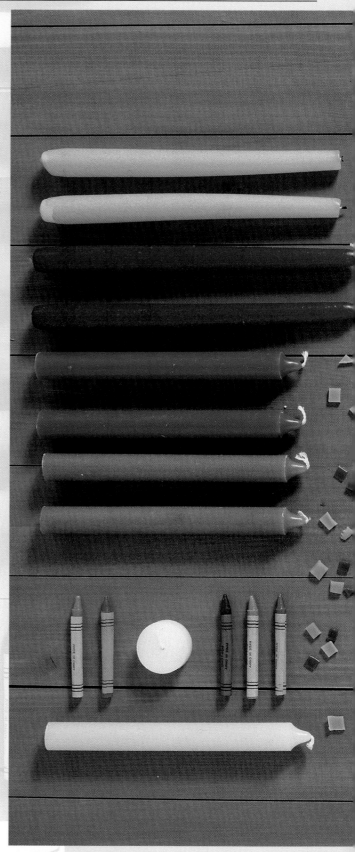

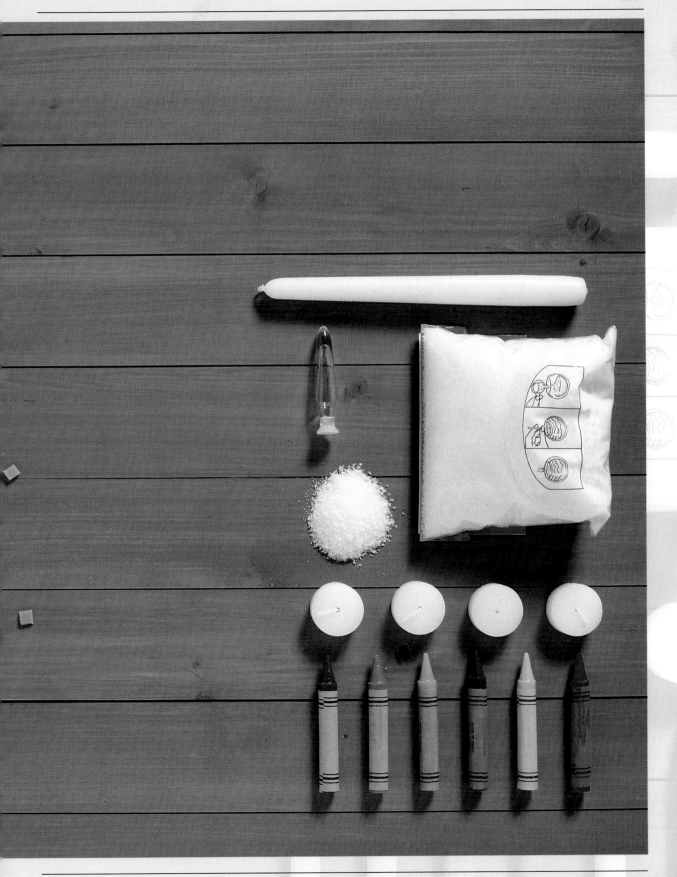

PICTURE FRAME WITH STARS

You can personalize your work with wax mosaic, since the squares used are created by you in form as well as in color. Tiles have been used in various shades of blue and combined with intense yellow squares that are the same shade as the central star in the frame shown here. The simplicity of this project and the pleasing final result will permit you to enhance even the most simple of picture frames.

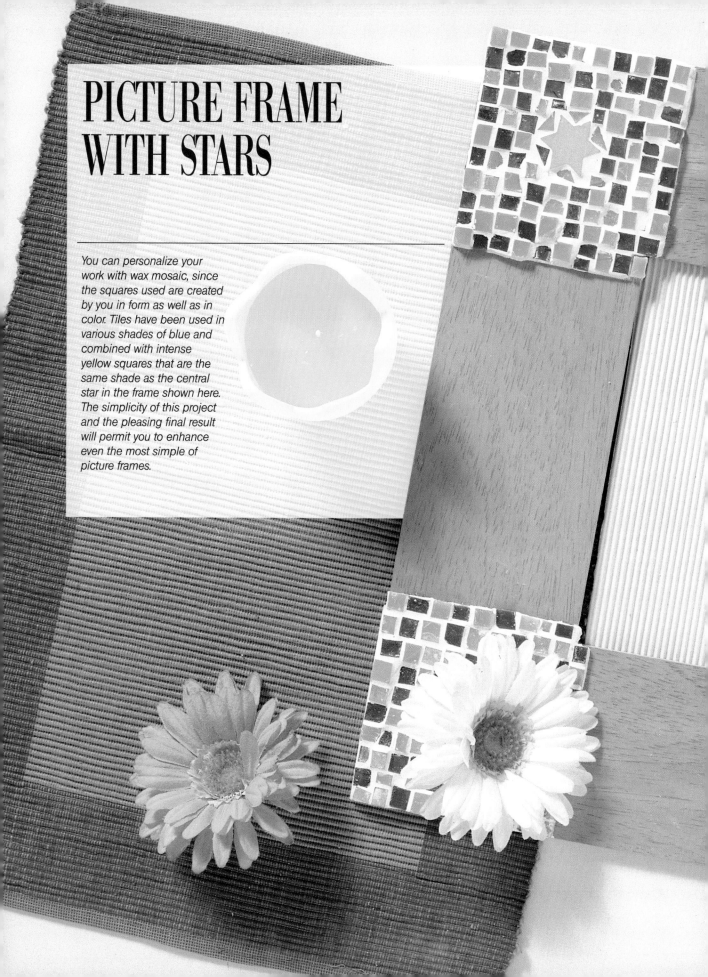

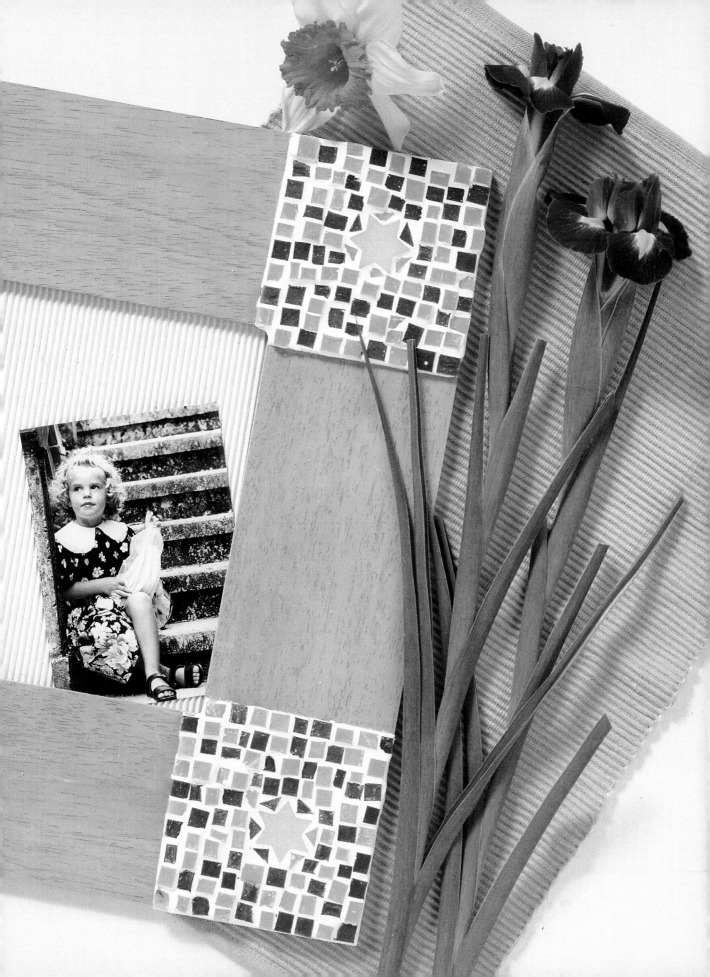

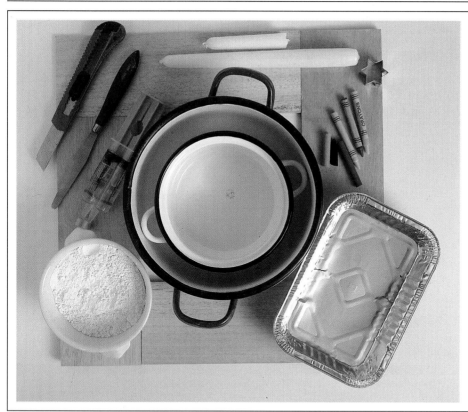

REQUIRED MATERIALS

AN UNTREATED WOODEN
PICTURE FRAME SIZED
35 x 35 CM
A STAR SHAPED COOKIE MOLD
WHITE CANDLES
WAX PASTELS
TWO COMPONENT EPOXY GLUE
A SPATULA
A CUTTER
CEMENT POWDER
THREE ALUMINUM CONTAINERS
TWO SAUCE PANS
DIMENSIONS
WATER
ACRYLIC BLUE COLOR
A PAINTBRUSH
STICKY TAPE

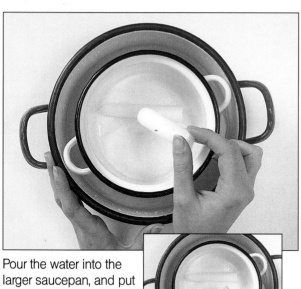

Pour the water into the larger saucepan, and put the smaller saucepan inside the larger pan. Put the candles at the bottom of the pan together with a yellow pastel crayon and let the wax melt at a bain-marie, at a low flame and at a constant temperature. When the wax has melted, remove the wicks and stir until you have obtained a homogenous yellow liquid.

Before pouring the yellow wax into the aluminum containers, be sure that you are working on a completely flat surface, so that the wax will be evenly distributed inside the container. Let it cool down. In the meantime, clean the pan thoroughly and continue with the realization of the blue wax.
Melt a white candle together with a blue pastel. Pour the wax into a second aluminum container. Repeat this operation for the light blue wax, incorporating only half a piece of the blue wax pastel crayon.

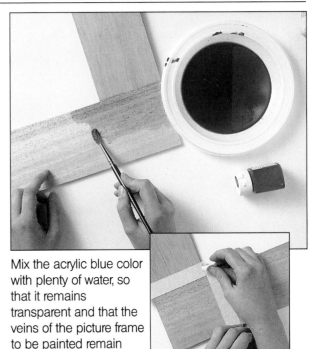

When the three layers have cooled slightly (they should still be warm to the touch) cut them rapidly into lots of equally sized squares using the cutter or a kitchen knife. Extract four shapes from the yellow wax using the star shaped cookie mold. When the squares and the stars have cooled completely and are completely hardened, remove them from the tray.

Mix the acrylic blue color with plenty of water, so that it remains transparent and that the veins of the picture frame to be painted remain visible. Cover the four angles of the frame in a square shape using the sticky tape.

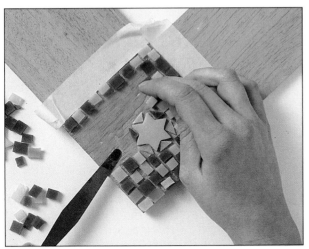

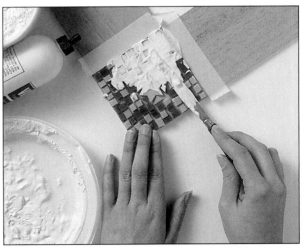

Mix the two component epoxy glue in a plastic plate and spread it onto a corner of the frame. Insert the yellow star first of all and then continue arranging the blue squares alternating them with the light blue ones. Continue in this way to cover the other corners.
When the glue has dried and the squares are well fixed to the frame, prepare the cement mix by mixing with one part water, one part vinyl glue and three parts cement powder.

Stir the cement, eliminating any lumps and apply to the corners of the frame so that it penetrates all nooks and crannies. When it is almost completely dry, clean the mosaic's surface, concentrating on each of the squares, with a dry cloth. Then remove the sticky tape and eliminate any imperfections.
When the cement has completely dried, clean the work another time using a dry brush in order to eliminate any further imperfections.

MOSAIC CANDLES
WITH PERFUMED WAX

Candles are beautiful and everlasting. They have always been a discreet furnishing accessory. You can transform them into elegant objects with the mosaic technique, like the ones in these pages, that have been completely adorned with perfumed wax squares. They are pleasing to the eye as well as emanating a wonderful scent when lit.

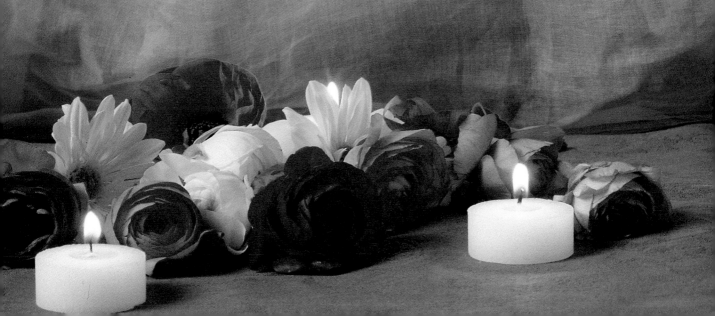

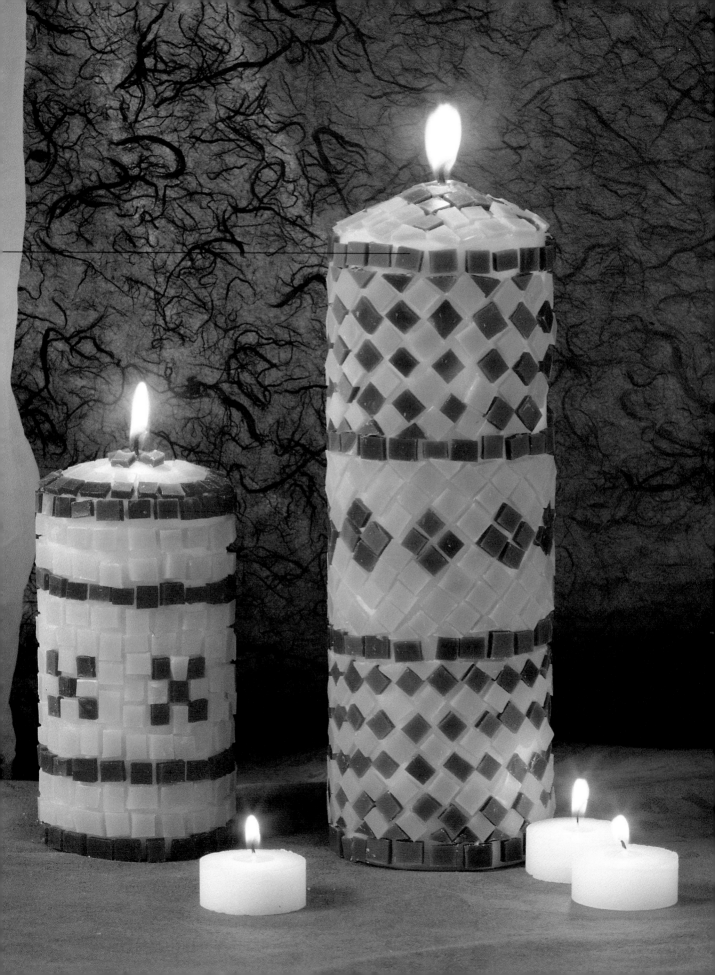

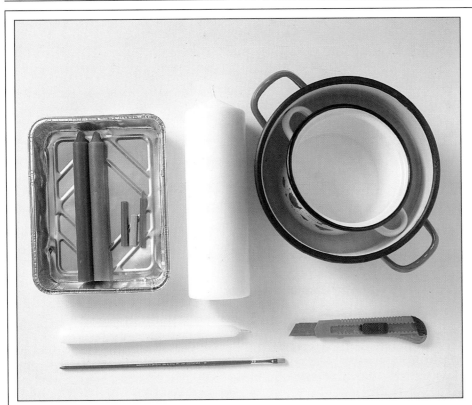

REQUIRED MATERIALS

A LARGE WHITE CANDLE
SMALLER WHITE CANDLES
TWO PERFUMED CANDLES: ONE
BLUE AND THE OTHER GREEN
WAX PASTEL CRAYONS
A CUTTER
A PAINTBRUSH
TWO DIFFERENT SAUCEPANS
DIMENSIONS
ALUMINUM CONTAINERS

Melt the perfumed candles with the bain-marie technique in two separate lots in order to obtain first a dark blue coloration followed by a light blue one. Each time, stir the wax well until the color is full and without graduations. Remember to remove the wicks once the candles have melted.

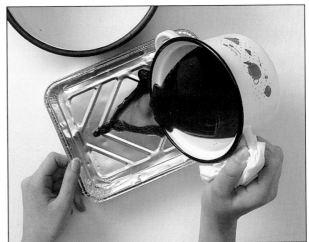

Before pouring the dark blue wax and the light blue wax into two different aluminum containers, be sure that you are working on a completely flat surface, so that the wax will be distributed evenly onto the base of the container. Hold the sauce pan with an oven glove or a kitchen towel so you don't get burnt.

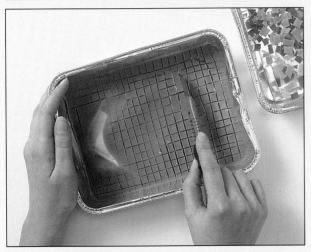

Cut the wax into a grill with the cutter when it is still tepid, being careful to engrave precise squares. This should be done as quickly as possible so that the wax does not cool down while it is being cut.

Melt a white candle with the bain-marie technique and when the wax has melted use it as glue (it will be always kept warm) to apply with the brush the various squares to decorate. For the mosaic, begin by dividing the candle into three parts starting with the dark blue squares.

Following this, using the hot wax as glue, arrange the light blue squares until you have completed the decoration. The candle will release the essences contained in the wax squares when lit.

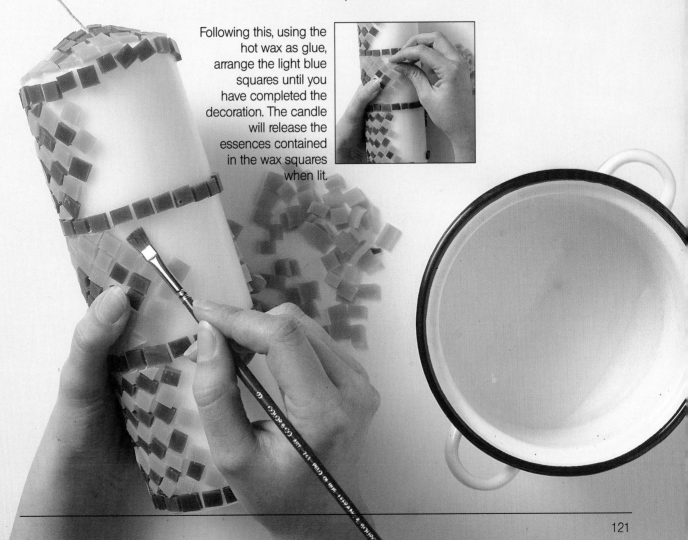

WARDROBE WITH WAX FLOWERS

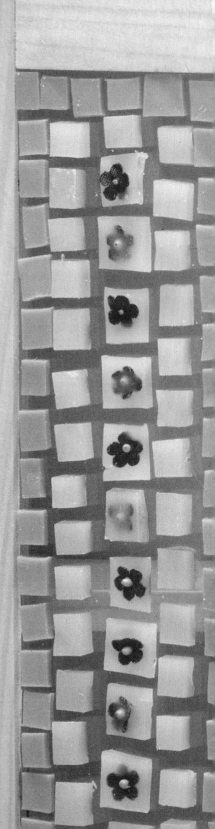

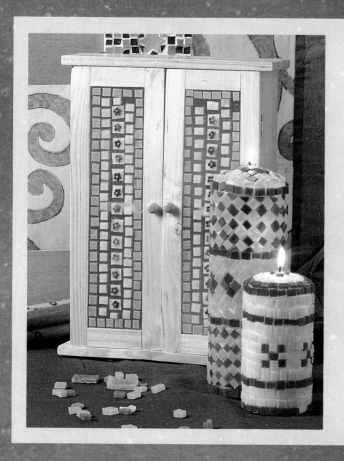

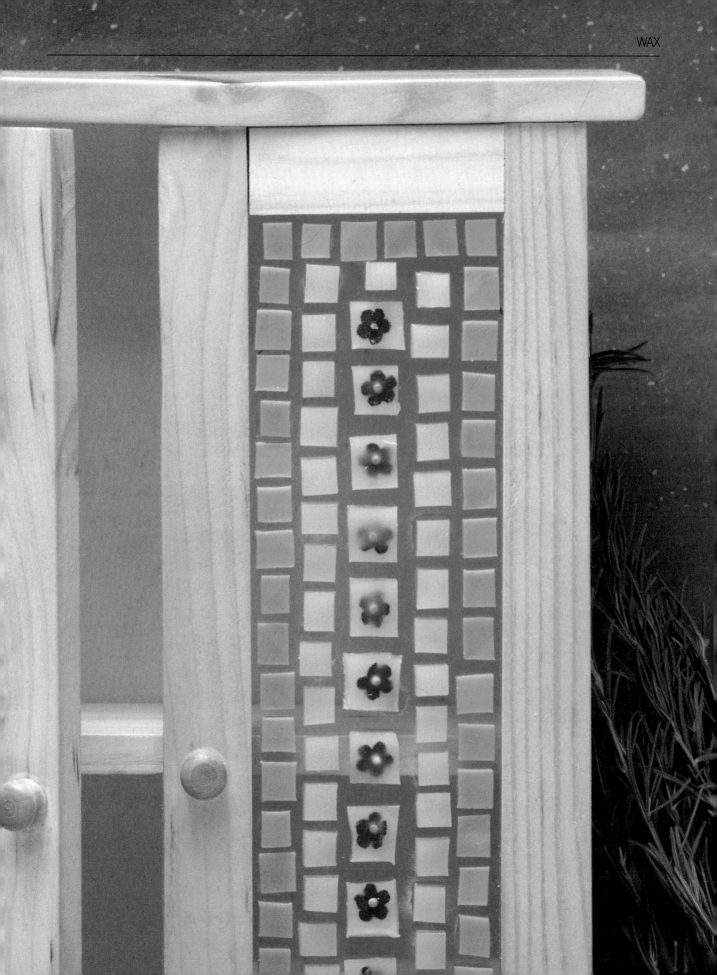

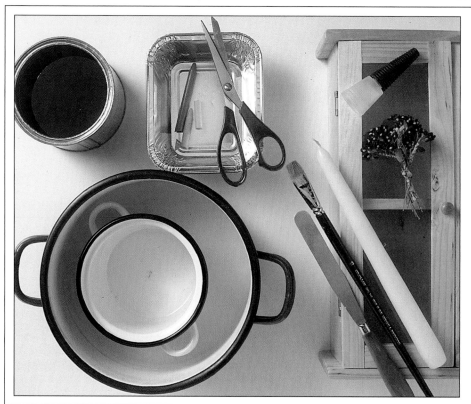

REQUIRED MATERIALS

A WOODEN WARDROBE WITH
TWO DOORS
A WHITE WAX CANDLE
WAX PASTEL CRAYONS
MATERIAL FLOWERS
FLATTING
A SPATULA
SCISSORS
STRONG GLUE
TWO SAUCEPANS
ALUMINUM CONTAINERS

Melt a couple of white candles with the bain-marie technique. Once the wax is completely melted, take out the wick using a small stick..

Pour the hot wax into a small aluminum container, on a flat surface. The layer of wax should have a thickness of 5mm.

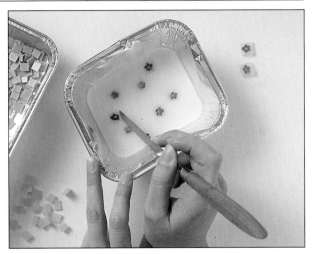

Cut out the flower shapes and immerse them into the wax that is still hot and liquid. Be sure to immerse them under a thin layer of wax without drowning them. Leave to cool.

Cut a square around each flower with the spatula and extract them from the container. Then, prepare the square of yellow and orange wax with the bain-marie technique using the wax pastel crayons.

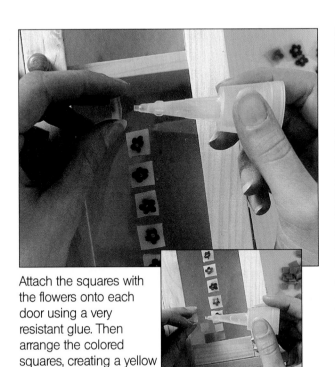

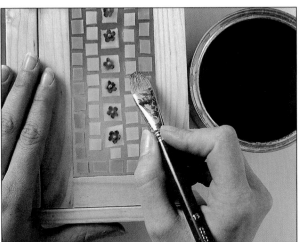

Attach the squares with the flowers onto each door using a very resistant glue. Then arrange the colored squares, creating a yellow and an orange border around each flowered row. Cover the two doors following this pattern.

Apply the first layer of flatting once the glue has dried and the squares are well fixed. Apply further hands of flatting in order to fix your work and make it water proof and washable.

IDEAS FOR VALENTINES DAY

Like the wax creations illustrated so far, the frame of this mirror has also been decorated with a mosaic of yellow, orange and red squares, combined haphazardly. The cover of the box, on the other hand, has been covered with a mosaic made out of red wax hearts, set in the center of white wax squares.
We arranged the squares with the hearts and then filled in the surrounding area with white wax squares.
Both are elegant objects in sunny tones, perfect for a San Valentine's day gift.

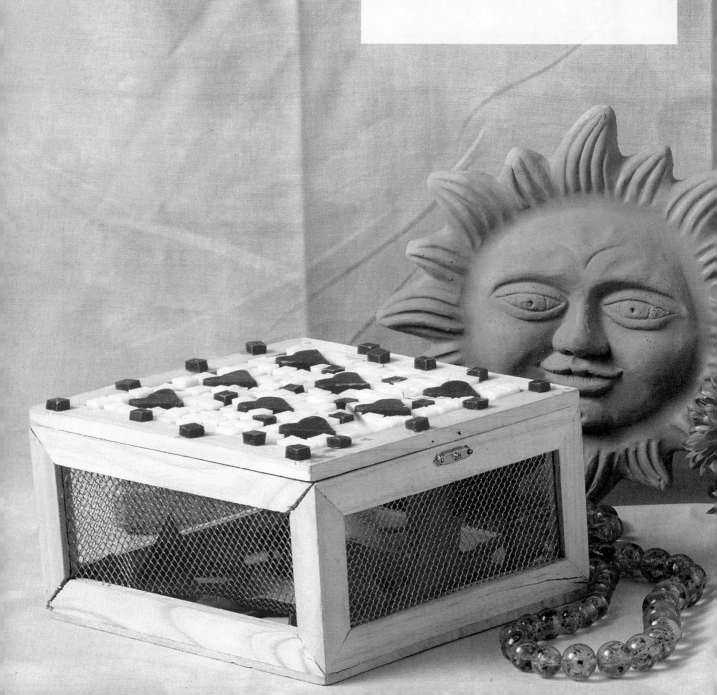

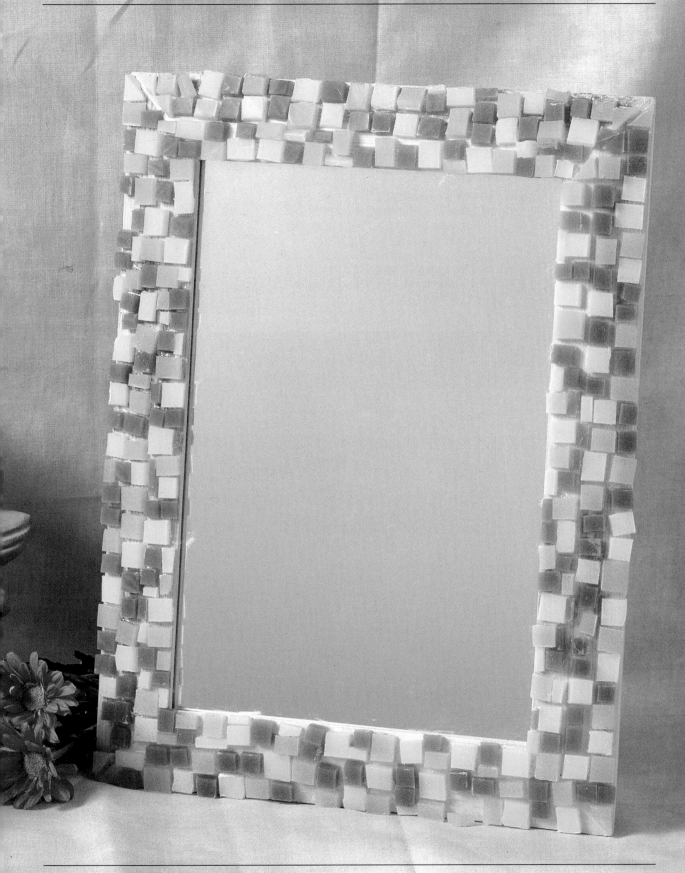

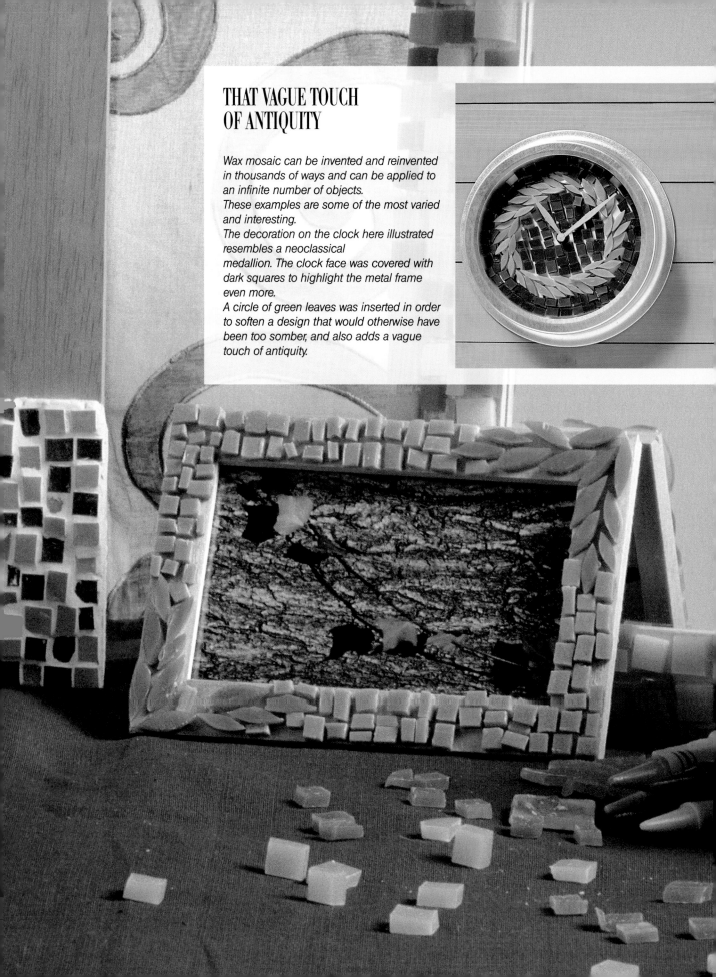

THAT VAGUE TOUCH OF ANTIQUITY

Wax mosaic can be invented and reinvented in thousands of ways and can be applied to an infinite number of objects.
These examples are some of the most varied and interesting.
The decoration on the clock here illustrated resembles a neoclassical medallion. The clock face was covered with dark squares to highlight the metal frame even more.
A circle of green leaves was inserted in order to soften a design that would otherwise have been too somber, and also adds a vague touch of antiquity.

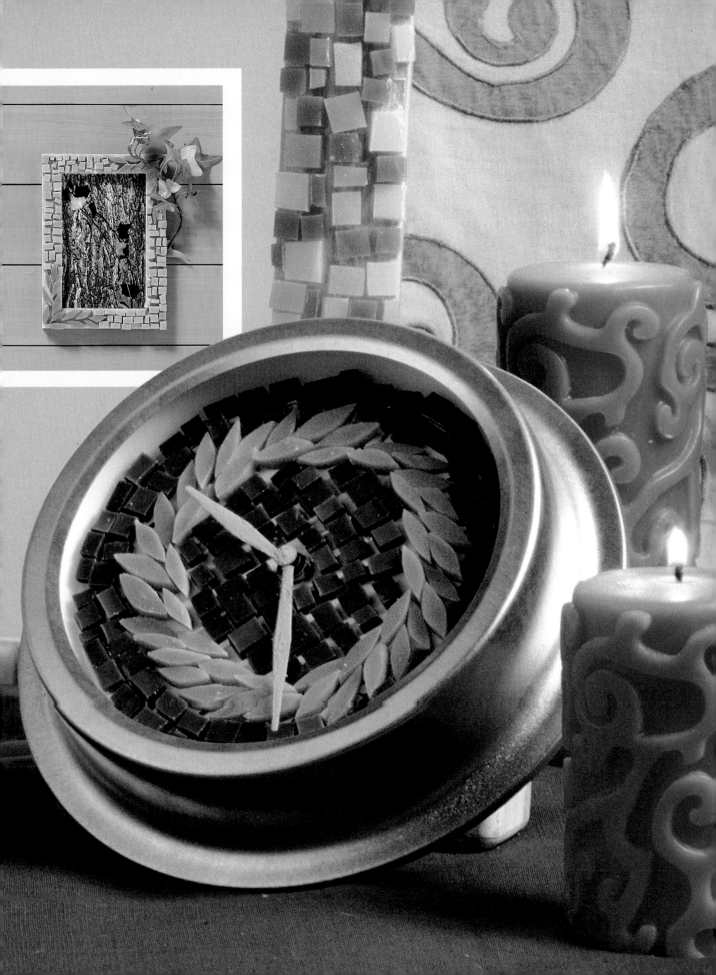

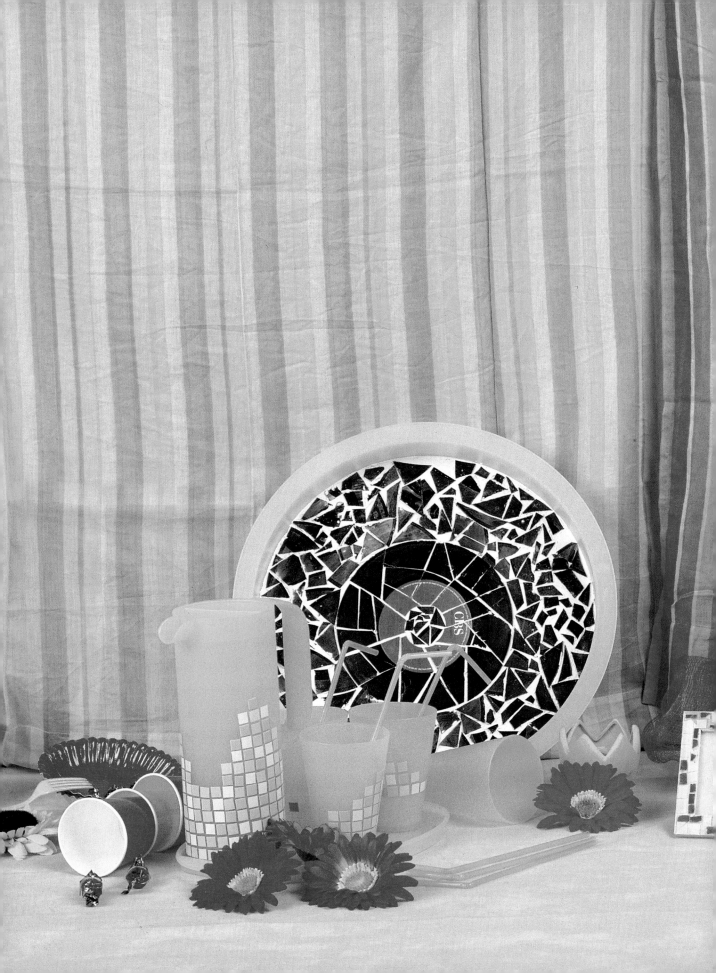

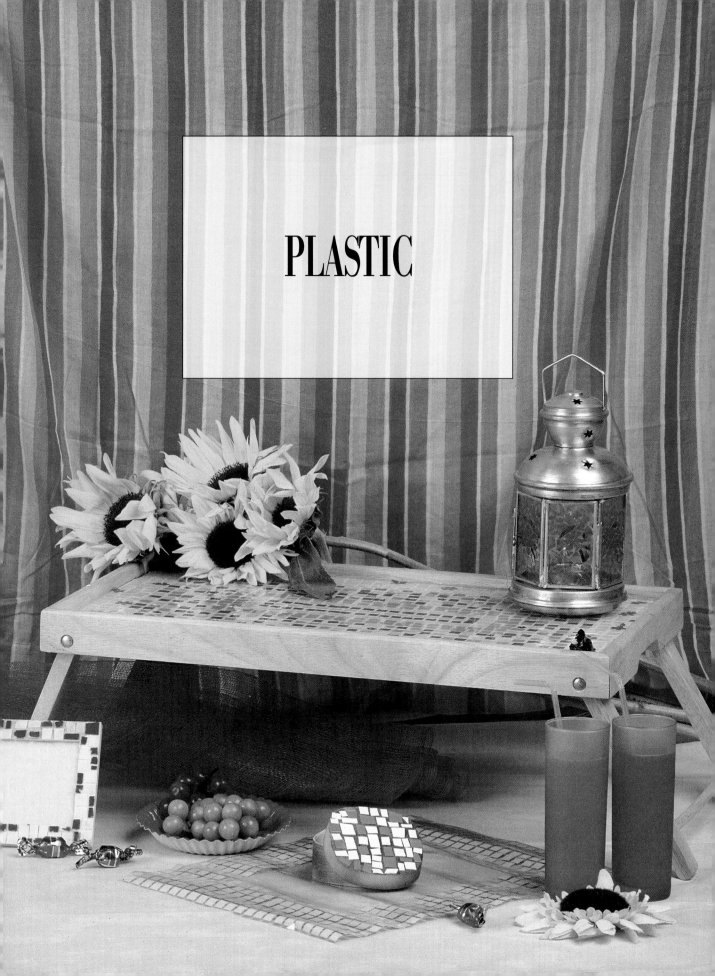

PLASTIC

MATERIALS

In this brief chapter, you will discover a series of interesting creative proposals that can be made with one of the most common and cheap materials available: plastic.

PLASTIC DRINKS BOTTLES: are ideal for making decorative objects. They are a support that can be easily decorated with glass colors. Thanks to their particular properties, the transparency of plastic bottles remains unchanged.

CONTAINERS FOR DETERGENTS AND CLEANERS: you can also keep the old containers of household cleaners. This type of plastic is slightly more rigid than drinks bottles, but equally workable.

PLASTIC STRAWS: straws for drinks can also create special objects and decorations. They are ideal for light and cheerful mosaics.

FOOD CONTAINERS: They are common vegetable containers to be found in any supermarket. They are easy to cut with a cutter or sharp scissors and are ideal for decorations.

VINYL: This is the black and resistant material used for making music records. If you do not have any records available you can easily purchase some at a reasonable price at flea markets. Rejects are also fine.

Up to here only some of the most common plastic objects have been mentioned, to which a long series of containers can be added in the strangest shades, obtained through recycling.

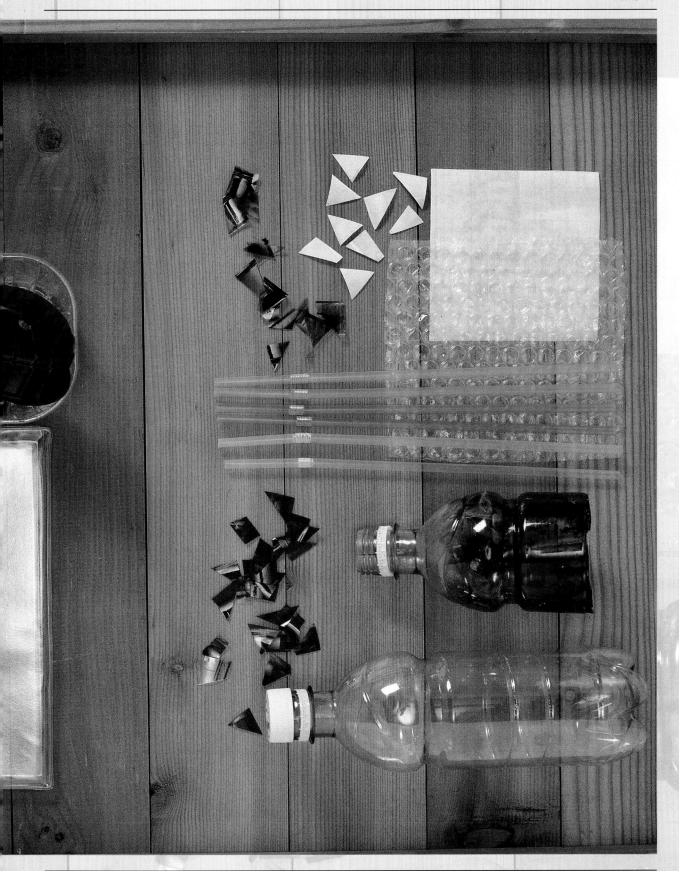

LANTERN WITH
RAINBOW REFLECTIONS

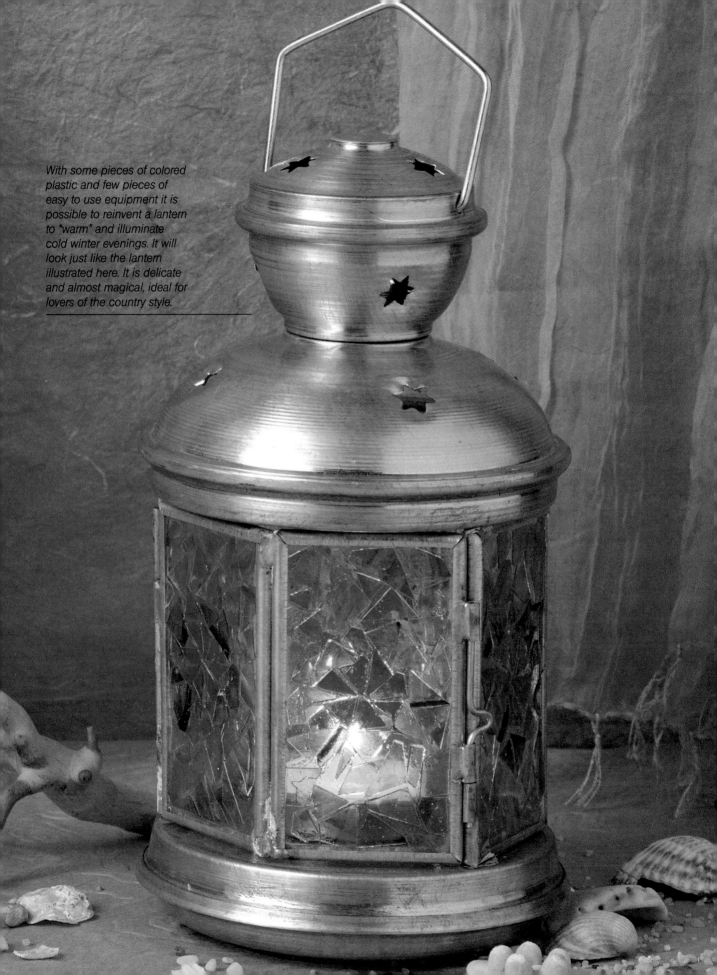

With some pieces of colored plastic and few pieces of easy to use equipment it is possible to reinvent a lantern to "warm" and illuminate cold winter evenings. It will look just like the lantern illustrated here. It is delicate and almost magical, ideal for lovers of the country style.

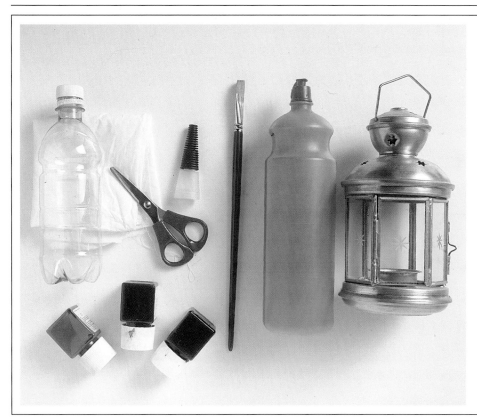

REQUIRED MATERIALS

A metal and glass lantern
Flat tipped N. 7 paintbrush
A cotton cloth
Scissors
Colors for glass: orange,
magenta and green
4 transparent 1 liter plastic
bottles
Universal glue
Alcohol

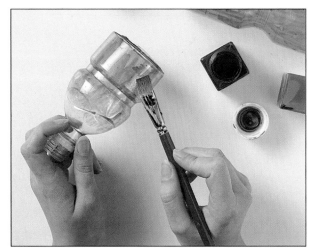

Cut the three bottles in half with the cutter and paint them with the three glass colors, applying the shades with the blunt tipped paintbrush. Leave to dry for 30 minutes.

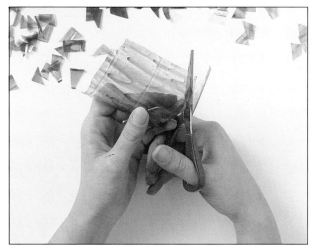

Cut up the bottles into lots of squares and triangles with the scissors which you will gather separately according to color.

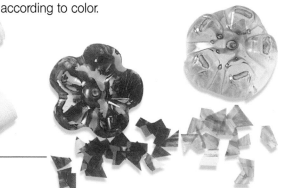

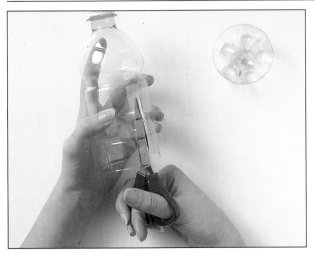

Now take a fourth bottle, that has been left unpainted, and cut it up into squares and triangles. Plastic bottles with a smooth surface are preferable to bottles with lots of grooves or markings.

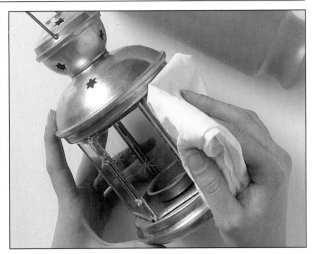

Carefully clean the glass surface of the lantern with a soft cloth and a bit of alcohol. This operation is indispensable. The glue will adhere perfectly to the surface to attach the decoration you have decided to make.

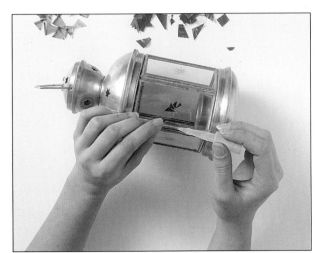

Begin with some magenta colored triangles: attach their unpainted side by fixing them on the center of each glass to create a kind of star or flower. Be careful not to use too much glue and not to blemish the glass surface.

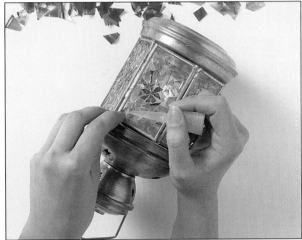

Start arranging the green squares around the central flower in a radial arrangement. Leave to dry. Complete covering the remaining surface with the orange and transparent squares. Continue in this way for the entire surface of the lantern.

BREAKFAST TRAY IN TECNICOLOR

This lively tabletop has been covered with squares cut out from colored plastic bottles, and protected with a transparent resin. The result is a true surge of color that will bring joy to your breakfast.

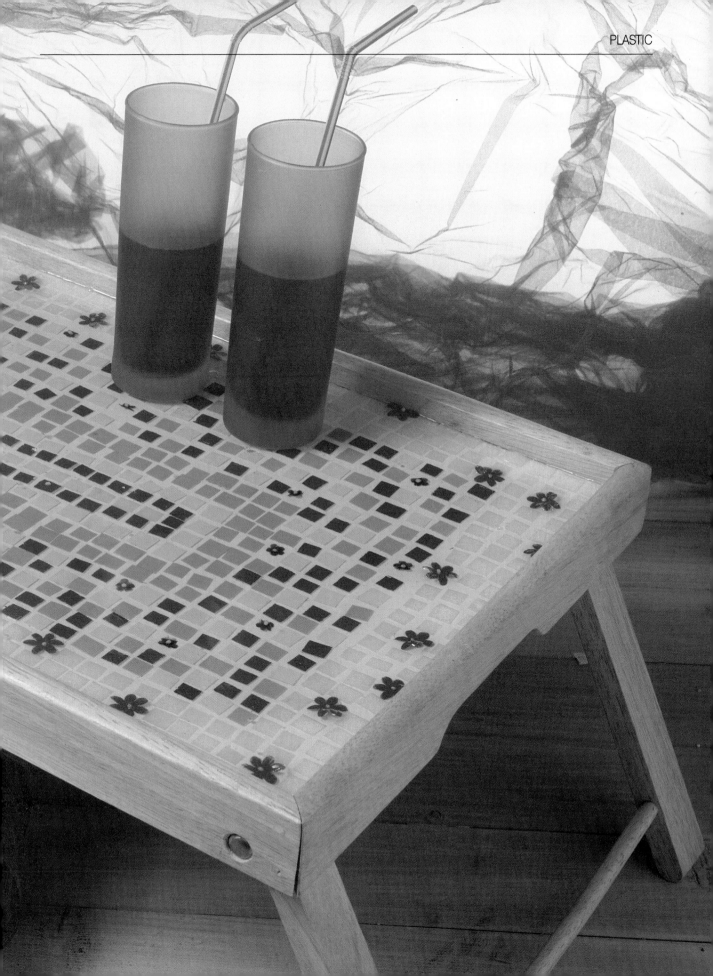

REQUIRED MATERIALS

COLORED PLASTIC BOTTLES
SCISSORS
A BREAKFAST TRAY
TWO COMPONENT EPOXY GLUE
RESIN FOR INCLUSION
SPATULA
CLOTH FLOWERS

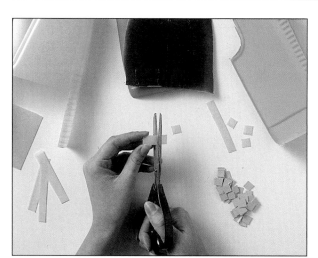

Cut out lots of equally sized columns from the plastic bottles. Then cut out squares, as identical as possible and sized 1 x 1 cm. Keep them separately.

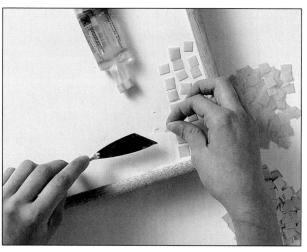

Mix the two component epoxy glue and apply using the spatula onto the first piece of the surface that is to be decorated. Neatly arrange the first yellow squares creating a border all around the tray.

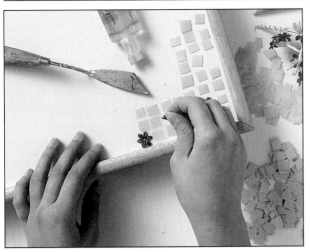

Alternate the plastic squares with small cloth flowers. Work on small parts at a time so that the glue will not dry before you have finished. Once all the squares have been applied, leave to dry.

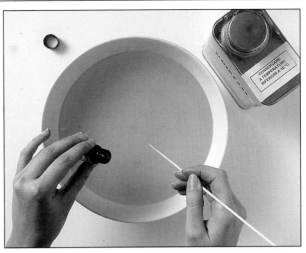

Now prepare the resin. Pour the thinner into a fairly large container and add the contents of the first component, following the usage instructions indicated on the packaging. Stir slowly using a wooden stick.

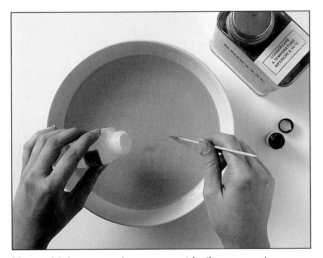

Now add the second component in the amount indicated in the instructions. Bear in mind that not all resins are the same; some require only two components.
Stir accurately with slow movements to prevent any bubbles from forming, which would complicate your work.

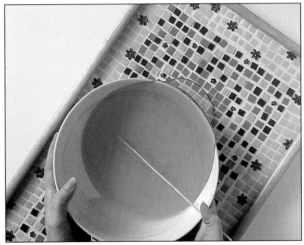

Working on a flat surface, slowly pour the resin into the tray covering the entire surface. Since the resin has an unpleasant odor, leave the table to dry for 24 hours in a well aired room, without touching it.
Once dried, the tray will be completely waterproof and ready for use.

MOSAIC PICTURE FRAME

All you need is a handful of plastic squares – cut out from plastic bottles – to enhance and cheer up a simple picture frame and transform it into an original gift idea.

TABLE WITH A TASTE OF SUMMER

The American tablecloth and the drinks set illustrated in these pages have been decorated with common adhesive plastic, normally used to cover shelves. Once you have decided on the decoration you want to achieve, all you need to do is cut out the plastic in squares and fix the bits onto the chosen objects to bring the table a taste of summer.

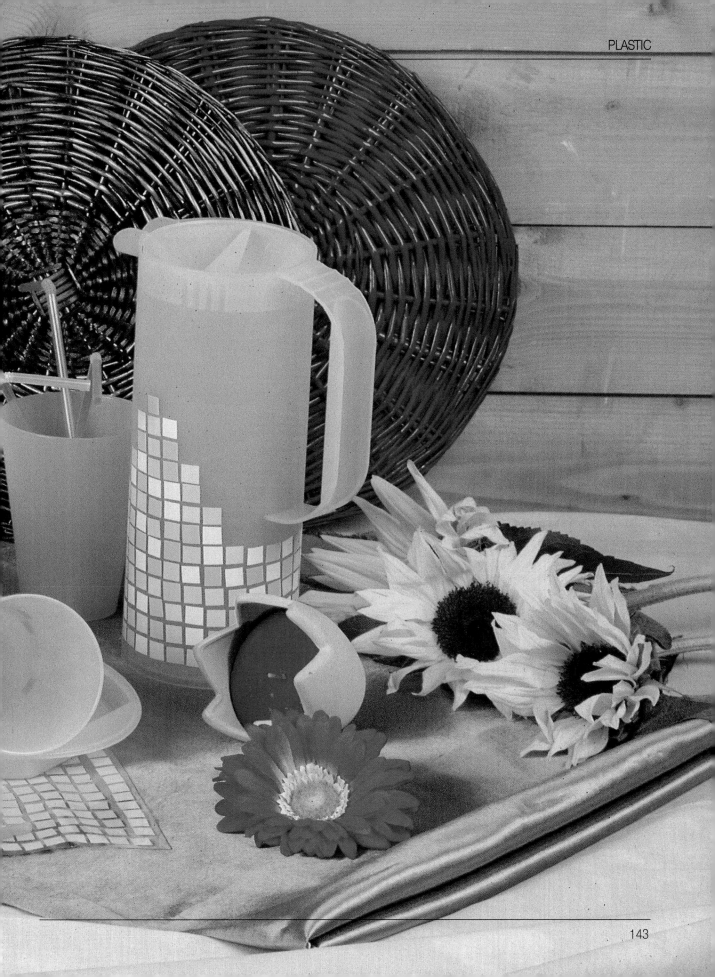

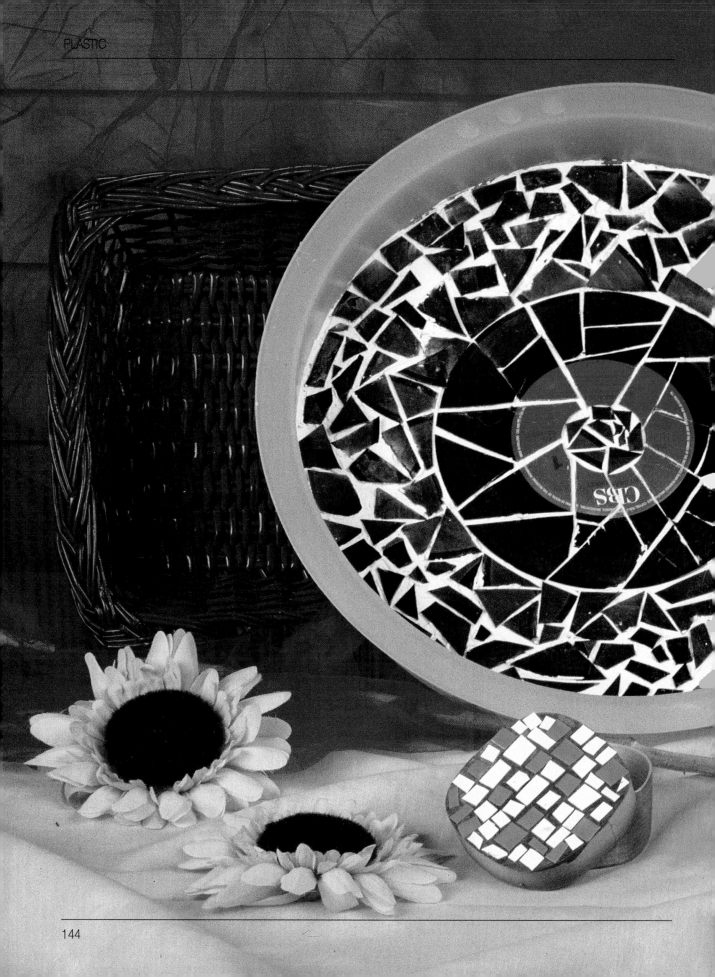

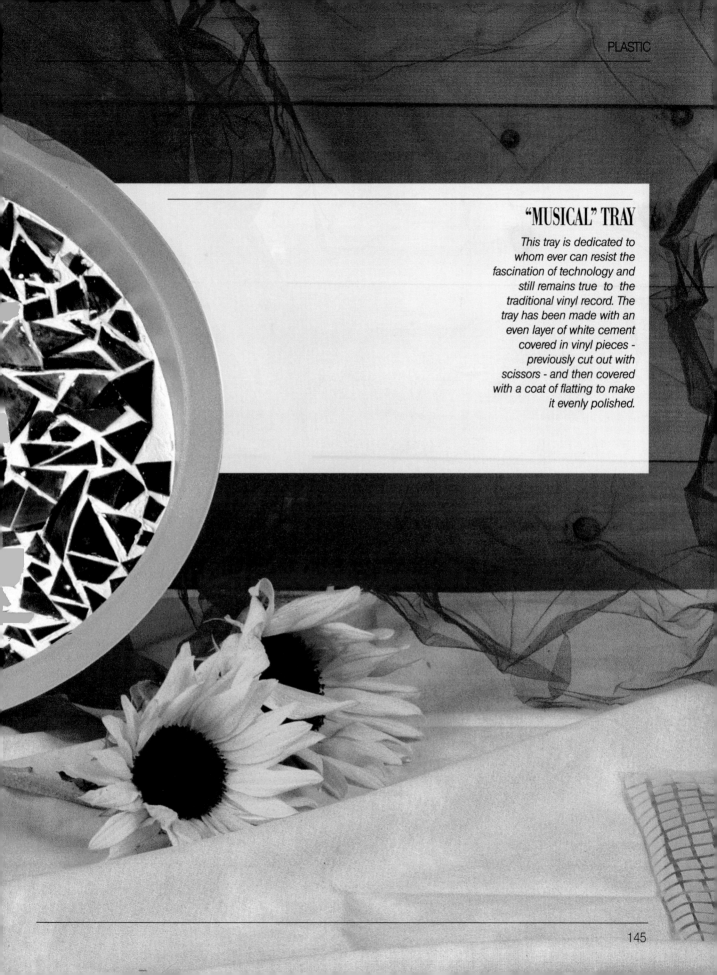

"MUSICAL" TRAY

This tray is dedicated to whom ever can resist the fascination of technology and still remains true to the traditional vinyl record. The tray has been made with an even layer of white cement covered in vinyl pieces - previously cut out with scissors - and then covered with a coat of flatting to make it evenly polished.

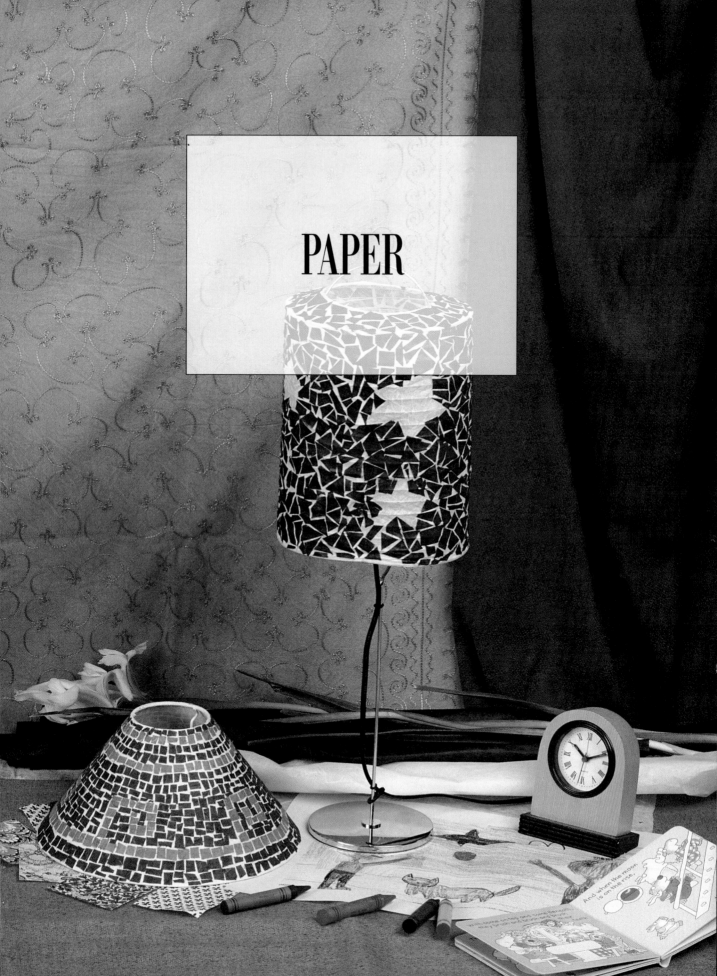

PAPER

MATERIALS

GIFT WRAPPING PAPER: wrapping paper is available everywhere, in large stores to stationary to specialized stores, in a vast choice of color and pattern.

RECYCLED PAPER: is usually worked and treated paper and slightly cheaper than normal wrapping paper. It is pretty and refined, and sometimes comes decorated with pressed flowers or is rather elegant like rice or coconut paper.

TISSUE PAPER: delicate and brightly colored, it is ideal for giving lightness to mosaics. You can find it in any stationary store.

NEWSPAPER: you can make professional mosaics with newspaper, or extravagant ones if the pages are painted first with a delicate watercolor tone.

DRAWINGS: If you are lucky enough to be immersed in kid's drawings, then you have a precious raw material for your mosaics. If want to keep the originals, you can make a photocopy and then cut them up.

POSTCARDS AND PHOTOS: the same goes for these as for the drawings, they can be photocopied and cut out to make romantic mosaic souvenirs of your holidays.

CARTOONS: in color, black and white, with Mickey Mouse, cowboys or super heroes, cartoons are magnificent for creating mosaics. And not only for kids!

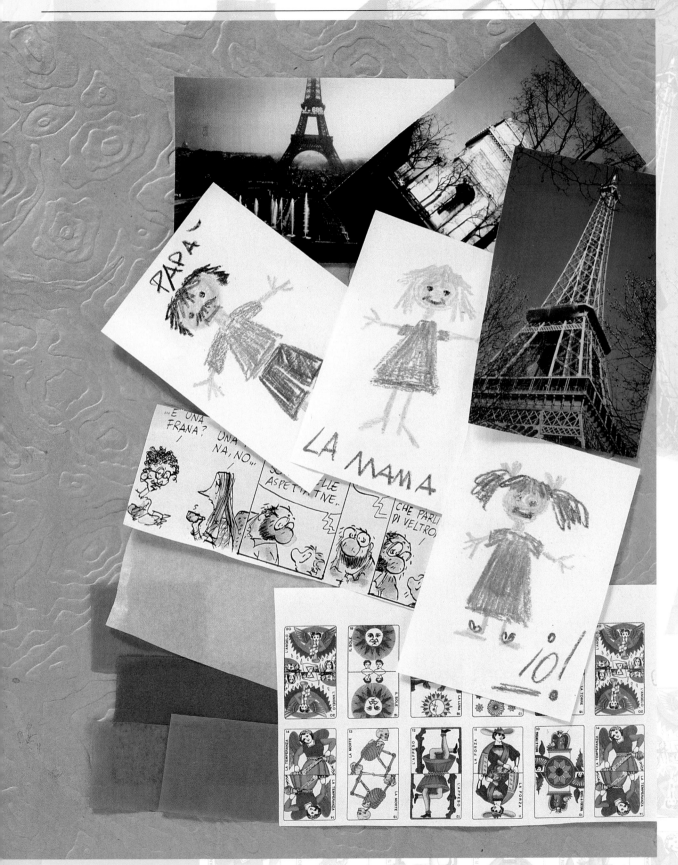

MOON AND STARS LAMP

All you need is your imagination and some pieces of natural and hand worked paper to completely transform a lamp into a romantic object. Like this Chinese lamp, reinvented with a mosaic made out of rice paper.

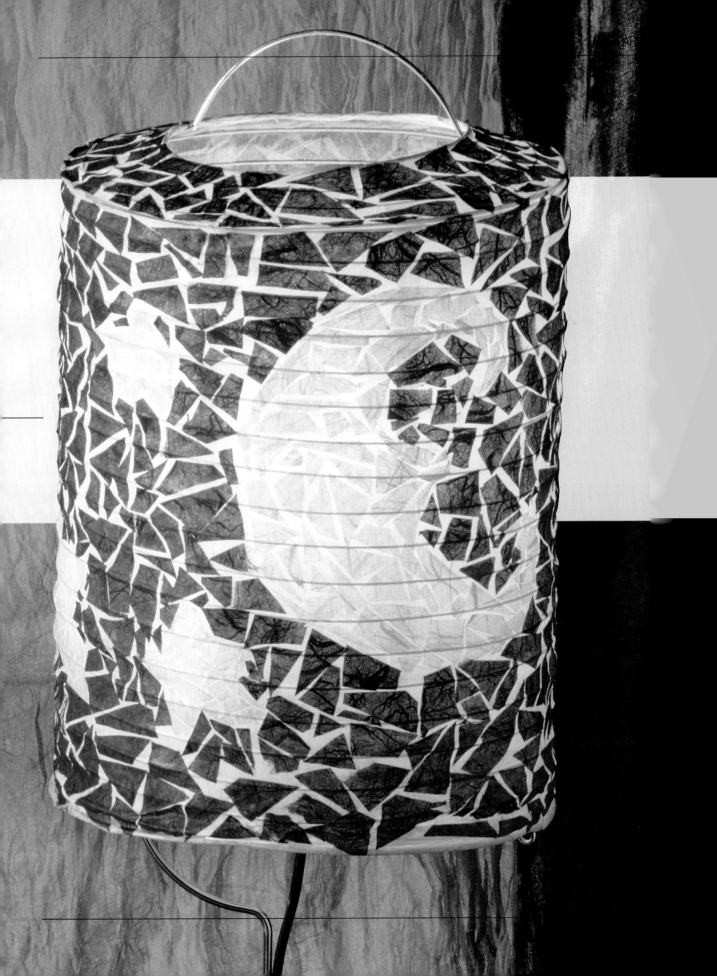

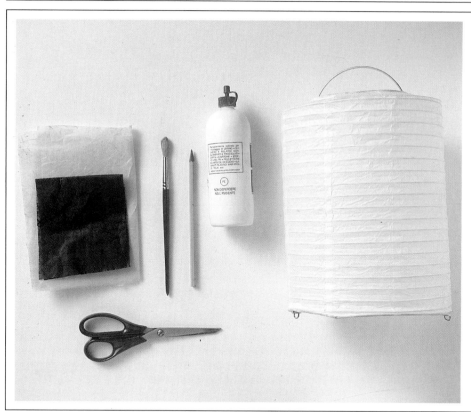

REQUIRED MATERIALS

A PAPER LAMP
A SHEET OF BLUE RICE PAPER
A SHEET OF YELLOW RICE
PAPER
FINE TIPPED PAINT BRUSH N. 4
A PENCIL
SCISSORS
VINYL GLUE
WATER

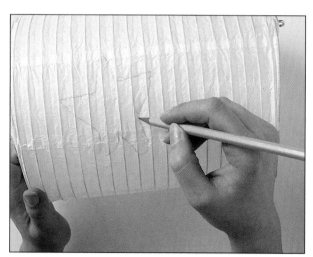

Draw the outline of the moon and stars straight on the surface of the paper lamp with a pencil. Proceed with extreme gentleness, so that you don't break the lamp. It would be best to use a blunt and soft pencil.

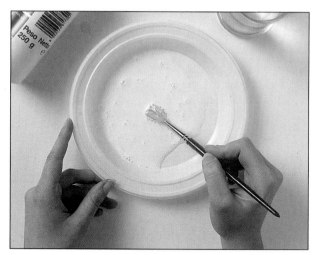

Mix up the vinyl glue with a little water in the plastic plate. Stir with the paintbrush. The glue should be fluid, to help the sticking of the paper bits and in order to dry faster.

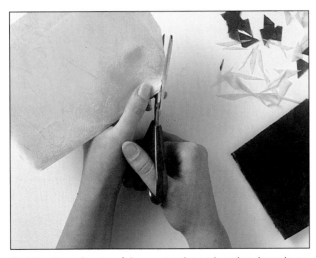

Cut the two sheets of rice paper into triangles, keeping the two colors separate. If there are left over pieces of paper you can keep them for future projects.

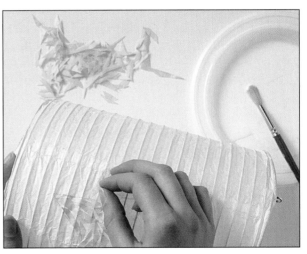

Spread a thin layer of glue inside the star shape and stick in the yellow paper bits, leaving a space of 2 mm between one piece and another. Proceed in this way for the remaining stars and with the moon.

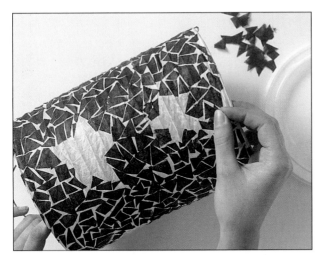

Once the stars and the moon have dried well, create the sky with the blue shapes. Apply a layer of glue on to a small portion of the lamp and then arrange the pieces of paper. Continue in this way, working on small portions at a time, so that you will always be working on fresh glue. Leave a space of 2 mm between one piece and the next also for the sky, so that the mosaic will stand out more.

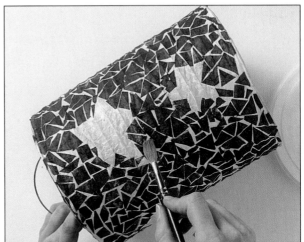

When you have finished applying all the pieces, leave to dry.
Dilute some more glue with water in the plastic plate and stir well with the paint brush and then apply it evenly onto the entire surface of the mosaic. This operation will protect your lamp from powder and will make it easier to clean.

A MOSAIC... AS A COVER

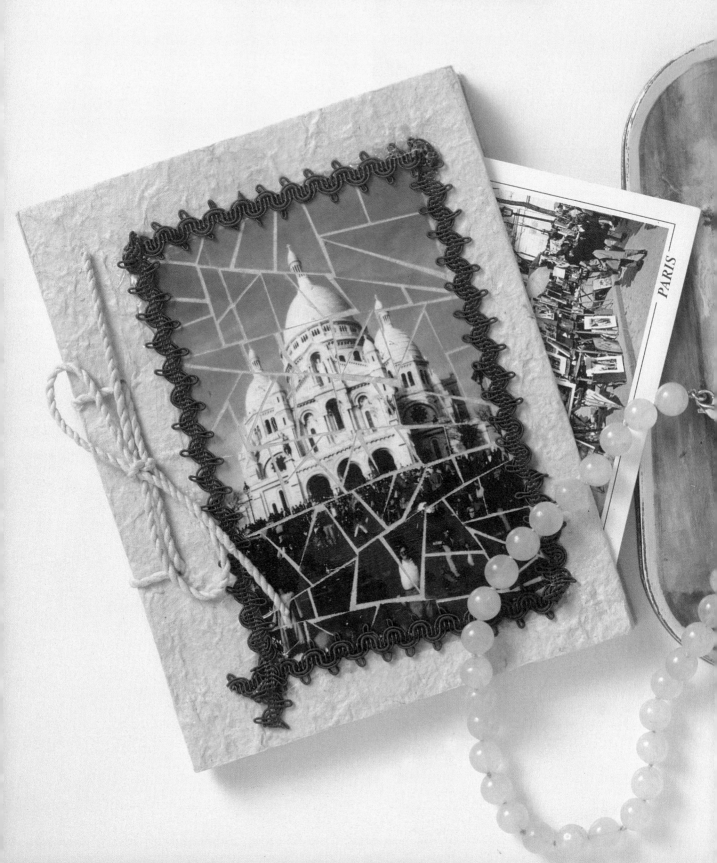

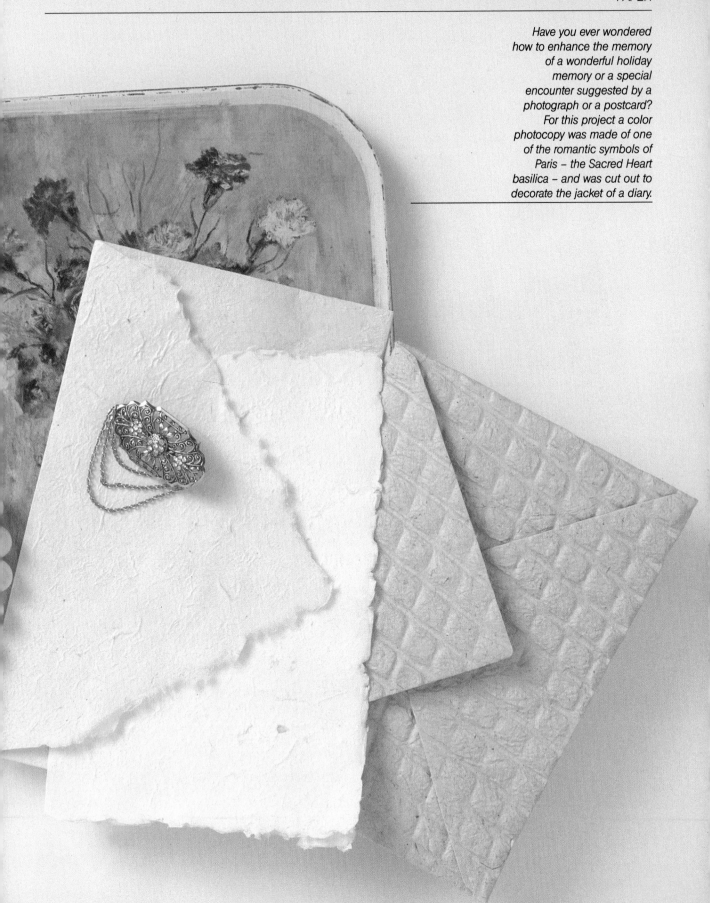

Have you ever wondered how to enhance the memory of a wonderful holiday memory or a special encounter suggested by a photograph or a postcard? For this project a color photocopy was made of one of the romantic symbols of Paris – the Sacred Heart basilica – and was cut out to decorate the jacket of a diary.

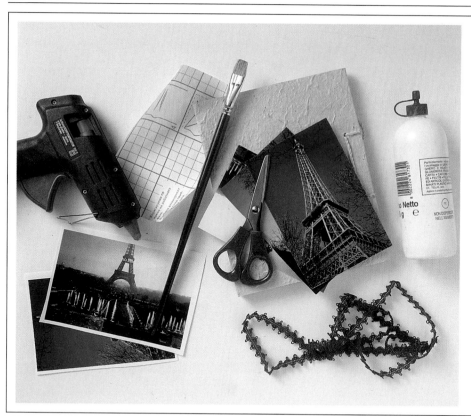

REQUIRED MATERIALS

A DIARY
SCISSORS
A COLOR PHOTOCOPY OF A
PHOTO OR A POSTCARD
VINYL GLUE
FLAT TIPPED PAINT BRUSH N. 5
HOT GLUE PISTOL
TRIMMING TAPE
TRANSPARENT ADHESIVE PAPER

Take the photo's or postcard's measurements and copy them at the center of the diary's cover with a pencil. Cut the photocopy in five asymmetrical parts with the scissors.

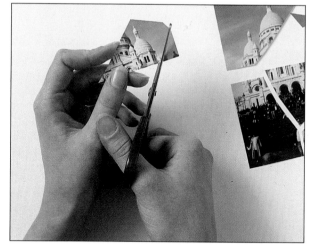

Cut each of the five portions of the photocopy into lots of small bits. As you cut, gradually recompose the pieces of the image to be arranged on the cover, keeping all the pieces close to the diary.

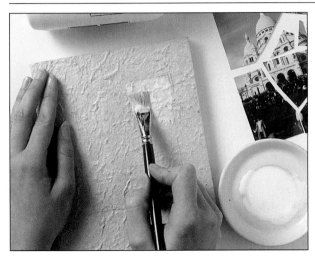

Pour a bit of the vinyl glue into a plate and dilute with some water (1 part water and three parts glue). Apply it with the paint brush inside square where the mosaic is to be arranged.

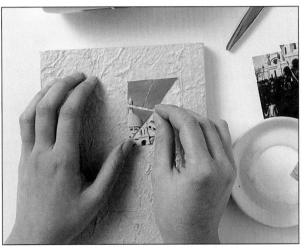

Reconstruct the image positioning the pieces inside the frame, keeping a small space
between one piece and another. Should the pieces get mixed up, you can always use the original photo to guide you.

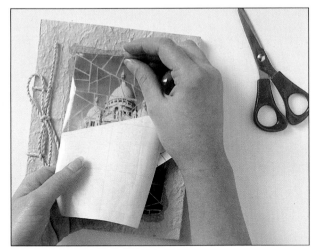

When the mosaic is completely dry, cut the transparent adhesive paper into the same size and apply it onto the mosaic to form a protective film.

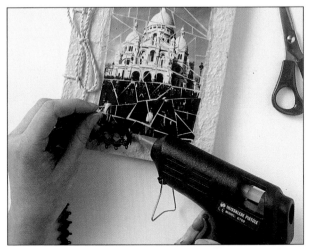

Now continue with the final decoration. Make a frame for the image with the trimming cord fixing it all around the mosaic with the hot glue. Leave to dry … and voilà!

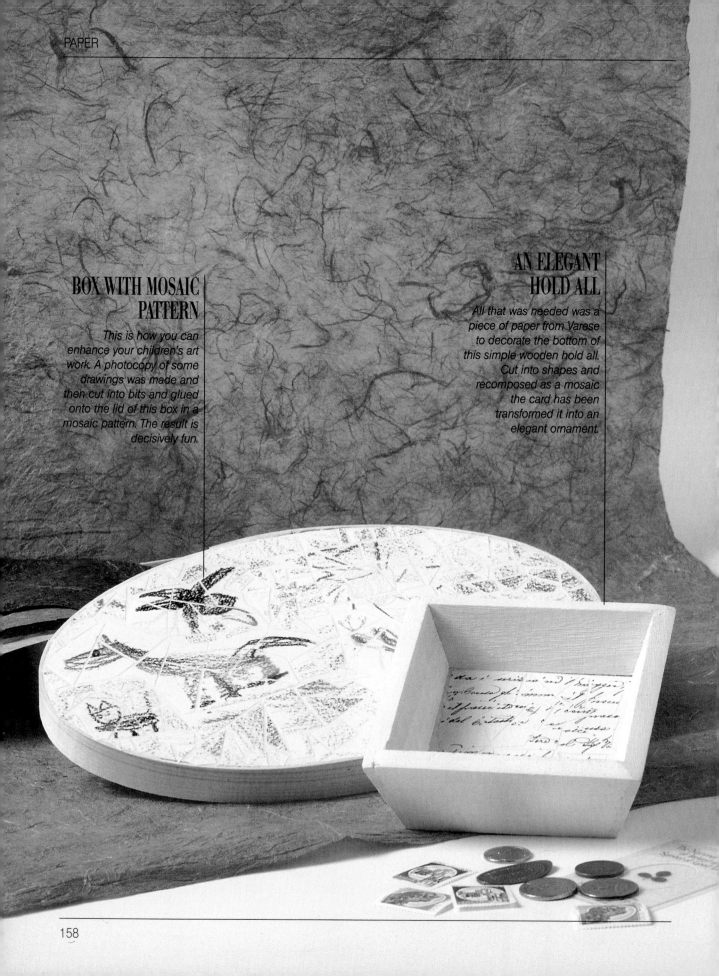

BOX WITH MOSAIC PATTERN

This is how you can enhance your children's art work. A photocopy of some drawings was made and then cut into bits and glued onto the lid of this box in a mosaic pattern. The result is decisively fun.

AN ELEGANT HOLD ALL

All that was needed was a piece of paper from Varese to decorate the bottom of this simple wooden hold all. Cut into shapes and recomposed as a mosaic the card has been transformed it into an elegant ornament.

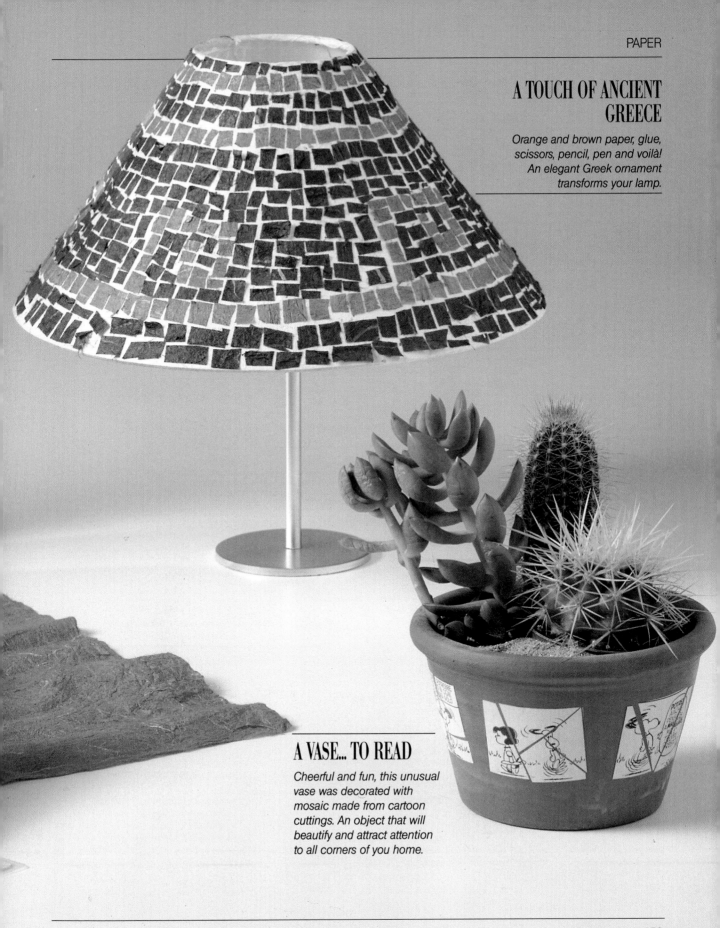

A TOUCH OF ANCIENT GREECE

Orange and brown paper, glue, scissors, pencil, pen and voilà! An elegant Greek ornament transforms your lamp.

A VASE... TO READ

Cheerful and fun, this unusual vase was decorated with mosaic made from cartoon cuttings. An object that will beautify and attract attention to all corners of you home.

INDEX

Acrylic colors, 12
Adhesives, 8-9
Azulejos tiles, 54
 blue, tray with, 72-73
 pavement insert, 66-67
 "sunny row" tray, 56-61
 tray with, 56-61

Balsa wood, 34
Bathroom tiles, 54
Book cover, 154-157
Bottle, embossed metal on blue glass, 104-107
Box
 hold all, 158
 for make up, 40-45
 with mosaic pattern, 158
 wood, 48
Breakfast tray, 138-141

Candle holder, 26-27
Candles
 mosaic, with perfumed wax, 118-121
 for wax projects, 112
Ceramic projects, 52-73
 hanging vase, with mosaic in terracotta, 62-64
 marine bedside table, 68
 materials, 54
 pavement insert, 66-67
 shelf with plate mosaic, 70
 street number sign, 70-71
 "sunny row of azulejos" tray, 56-61
 tray with blue azulejos, 72-73
Christmas balls, decorative, 18-21
Color, 12-13, 34
Cork and wood projects, 33-51
 box, 48
 classic table, 36-39
 magazine holder with mordant dye, 46-49
 make up box, 40-45
 materials, 34
 mirror of stars, 50-51
 plate with tulips, 50
 vase, 49
Cups, 54
Cutting equipment, 10-11

Doors, wardrobe, 82-87
Drinks and tablecloth set, 142-144

Embossed metal on blue glass, 104-107
Epoxy glue, 8

Food containers, for plastic projects, 132
Full color, 34

Garden table, 78-81
Glass, 16
Glass colors, 12-13
Glass cutter, 11

Glass projects, 15-21
 candle holder, 26
 decorative Christmas balls, 18-21
 lamp with colored glass and glass gems, 22-25
 materials, 16
 picture frame with painted glass, 30-32
 using mirror glass, 28
 vase with glass gems, 26
Glues, 8-9
Gold sheet, 34
Greek lamp, 159

Hammer, 11
Hanging vase, with mosaic in terracotta, 62-64
Hold all, 158

Kitchen tiles, 54
Knife, 11

Lamp
 with colored glass and glass gems, 22-25
 Greek, 159
 moon and stars, 150-153
Lantern with rainbow reflections, 134-137

Magazine holder, 46-49
Make up box, 40-45
Marble effect, 34
Marine bedside table, 68-69
Materials. See under specific projects
Metal projects, 97-110
 embossed metal on blue glass, 104-107
 materials, 98
 vase with Argentinean wave, 100-103
Mirror
 glass, broken, 28-29
 of stars, 50-51
Mission glue, 48
Moon and stars lamp, 150-153

Natural projects, 75-96
 garden table, 78-81
 materials, 76
 seeds and marble fragments, 92
 spoons with egg shells, 88-91
 wardrobe doors, 82-87

Paintbrushes, 13
Paper projects, 147-159
 book cover, 154-157
 box with mosaic pattern, 158
 Greek lamp, 159
 hold all, 158
 materials, 148
 moon and stars lamp, 150-153
 vase to read, 159
Pavement insert, 66-67
Perfumed essences, for wax projects, 112
Picture frame

with painted glass, 30-31
plastic mosaic, 142-144
with stars, 114-117
Plastic projects, 131-146
 breakfast tray, 138-141
 lantern with rainbow reflections, 134-137
 materials, 132
 mosaic picture frame, 142-144
 "musical" tray, 145
 tablecloth and drinks set, 142-144
Plates, for ceramic projects, 54
Plate with tulips, 50

Scalpel, 11
Scissors, 10
Sheet or embossing metal, 98
Shelf with plate mosaic, 70
Silicone, 8
Spoons with egg shells, 88-91
Street number sign, 70
Sunny Row of Azulejos project, 56-61

Table
 classic, 36-39
 garden, 78-81
 marine bedside, 68-69
Tablecloth and drinks set, 142-144
Terracotta
 for ceramic projects, 54
 hanging mosaic vase, 62-64
Tiles, 54
Tray
 with Azulejos tiles, 56-61
 breakfast, 138-141
 "musical," 145
Triangle, 13

Vase
 with Argentinean wave, 100-103
 with glass gems, 26-27
 hanging, with mosaic in terracotta, 62-64
 "to read," 159
 wood mosaic, 49
Vinyl, 132

Wardrobe
 doors, 82-87
 with flowers, 122-125
Wax projects, 111-130
 glues for, 8
 ideas for, 128
 materials, 112
 mosaic candles with perfumed wax, 118-121
 picture frame with stars, 114-117
 Valentines day ideas, 126
Wardrobe with flowers, 122-125
Wood, 34
Wood projects. See Cork and wood projects